IMAGES
of America

THE BRADFORD
OIL REFINERY

On the cover: Photographed in 1984, the year before the present crude unit was erected, this panoramic view of the refinery is a common sight to travelers on U.S. Route 219 as they travel north. The refinery has been at this same location for 125 years and is the oldest continuously operating refinery in the United States, and the oldest continuously operating crude oil processing refinery in the world. (Courtesy of American Refining Group.)

THE BRADFORD OIL REFINERY

IMAGES
of America

Sally Ryan Costik
Foreword by Harvey L. Golubock

Copyright © 2006 by Sally Ryan Costik with foreword by Harvey L. Golubock
ISBN 978-0-7385-4522-6

Published by Arcadia Publishing
Charleston, South Carolina

Printed in the United States of America

Library of Congress Catalog Card Number: 2006922700

For all general information contact Arcadia Publishing at:
Telephone 843-853-2070
Fax 843-853-0044
E-mail sales@arcadiapublishing.com
For customer service and orders:
Toll-Free 1-888-313-2665

Visit us on the Internet at www.arcadiapublishing.com

We are now celebrating the 125th anniversary of the Bradford, Pennsylvania, refinery and in 2007, will celebrate the 10th anniversary of the refinery under American Refining Group's ownership. We remain committed to the founding principals of our business, producing quality products at a fair price and exceeding our customers' expectations. We could not have accomplished this without the dedication and commitment of all of our employees, and it is to them and their predecessors that this book is dedicated. It is truly a "Celebration of Achievement."

Contents

Acknowledgments — 6

Introduction — 7

1. Refining the Crude — 9

2. Sunny Days Ahead — 21

3. Working Hard for Tomorrow — 37

4. Progress in Peacetime — 61

5. Changing Times — 77

6. The Refinery of Today — 97

Acknowledgments

Writing a book on a highly technical subject like oil refining requires the assistance of dozens of people including current employees Kathleen A. Alexander, Bev Danielson, John A. Cannella, Helen M. Cumminskey, Richard A. Douthit, Dawn Bernhard Kozminski, Judy L. Larson, Charlotte Loudermilk Layton, Ronda D. Lasseter, C. David Lerch, Susan M. Lerch, Susan S. Oliphant, Thomas L. Oliphant, Susan VanNette Sinclair, Jennifer M. Taylor, Amy F. Tyger, Carol White, and of course, Harvey L. Golubock, the president of American Refining Group. Retired refinery workers Jim Zetts, Larry O. Stranburg, Marie J. Milks, Gerry Cookson, and Fred Matvias were invaluable in explaining the photographs and telling stories of "the old days." Fellow historians Sherri L. Huston-Schulze and Susan Gibson Perry from the Pennbrad Oil Museum; and volunteers from the Bradford Landmark Society Molly Lindahl, Mary Ryan, Larry Richmond, and Patricia Schessler were always ready to look up something, verify a date, or suggest a photograph of interest. Photographer Fred Proper contributed wonderful images that make up the backbone of this book and are much appreciated. And of course, to all those employees of the American Refining Group who offered photographs, memories, and, more importantly, encouragement, many thanks for your contributions to this production commemorating the 125th year of the Bradford, Pennsylvania, refinery.

INTRODUCTION

It is with great pride that we offer you, our readers, a brief history of our refinery. It is a success story, a "celebration of achievement" that has developed over 125 years of uncompromised commitment to quality, devotion to details, and an unwavering entrepreneurial spirit. It is the story of generations of people whose ancestors started this refinery with the pioneering spirit that has made this such a great country. Today Bradford, Pennsylvania, may be known only on the Weather Channel as the coldest spot in the nation, but long before the Weather Channel even existed, Bradford was the energy capital of the United States. In 1859, the first commercial oil well was drilled in Titusville, and five years later oil was discovered in Bradford. The Bradford field proved to be among the most prolific of the early finds. In 1881, over 83 percent of the country's oil came from Bradford. Our refinery, established in 1881, is now the oldest refinery in the world continuously processing crude oil. We refine select Pennsylvania Grade crude oil to produce the finest lubricants, solvents, and petroleum specialties.

At the height of the oil boom, there were numerous refineries in Pennsylvania owned by such recognized names as Pennzoil and Quaker State. All have been shuttered and, for the most part, torn down. American Refining Group's Bradford refinery remains an anomaly in the world of mega-refineries. Processing a mere 9,000 barrels a day of Pennsylvania Grade crude oil, we represent less than .05 percent of the country's refining capacity. Yet we have managed to carve out a niche for our products and services. It was not always so.

At the start of its proud heritage, the refinery was part of an independent company that sold premier lubricants under the Kendall brand name. In 1966, the Kendall Refining Company was acquired by Witco Corporation, acting as a white knight, fending off the unwanted advances of Kewanee Oil. Witco owned the refinery and Kendall brand until 1996, when the brand was sold to Sun Oil Company. The refinery and most of its associated blending facilities were unwanted by the new owner of the brand. In March 1997, faced with the possibility of an imminent shutdown by Witco, the refinery was again saved by a white knight. Harry Halloran Jr., the principal shareholder of American Refining Group Inc., purchased the Bradford refinery. Halloran understood the proud heritage of the refinery and was especially impressed by the commitment and dedication of its workforce.

The first three years under American Refining Group's ownership were very difficult, as the refinery had to reestablish its position as a producer of quality lubricants. To his credit, Halloran stuck with it, despite the dire predictions of most industry pundits. We have grown from 157 employees in March 1997 to over 265 employees in 2006. We have established a finished lubricants business that generates over $80 million in revenue (from $0 in 1997), and we count among our customers some of the most familiar names in the lubricants industry. In the recent crises of 2005, brought on by the hurricanes that affected the Gulf Coast this, we

were able to supply product to other refiners and marketers who were adversely impacted by the storms. Over two-thirds of the crude oil processed by the Bradford refinery comes from within 125 miles of Bradford, Pennsylvania. We purchase much of our other raw materials and supplies from local sources. Our wage rates and subsequently our payroll are among the highest in the region. Our small refinery is truly an economic engine fueling growth in rural northwest Pennsylvania.

Our future remains bright. The shared vision that we committed to several years ago remains a fundamental principle of our business: "To be an organization committed to the development, production, and marketing of specialty petroleum products, embracing personal development, community partnership and environmental responsibility." The business is only on loan to us to build for the next generation. That is our legacy.

—Harvey L. Golubock,
President and Chief Operating Officer, American Refining Group

One

REFINING THE CRUDE

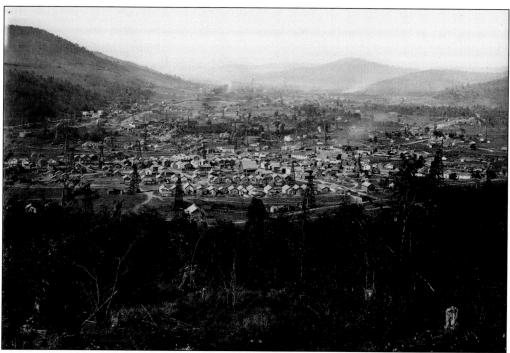

This is Kendall Creek/Tarport as it appeared in 1879. A peaceful valley, filled with promise, was the inspiration for John A. Mather of Titusville, a renowned regional photographer of the Pennsylvania oil fields. This photograph, looking toward the north, shows the village of Kendall Creek in the Tunungawant Valley. Often called Tarport, this small community changed its name in 1841 when a petition to then U.S. postmaster Amos Kendall was approved for an official post office. In 1892, this area was annexed into the city of Bradford, becoming the Sixth Ward district. The refinery was built within the next two years, in 1881, and was located near the area at the upper left-hand side of the photograph. Close examination of this photograph shows several large oil tanks and many derricks; the establishment of a refinery here was an obvious choice.

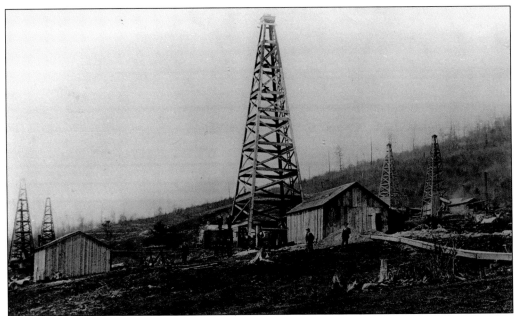

The Jackson Walker Well is seen here in 1875. Drilled on the hillside above present-day Jackson Avenue on land owned by Peter Kennedy, this well was drilled by Isaac Jackson and Asher Walker. Both men became successful oil producers, and each had a street in Bradford named after him—Jackson Avenue and Walker Avenue. One of their large oil storage tanks can be seen in the photograph of the Kendall/Tarport valley in 1879.

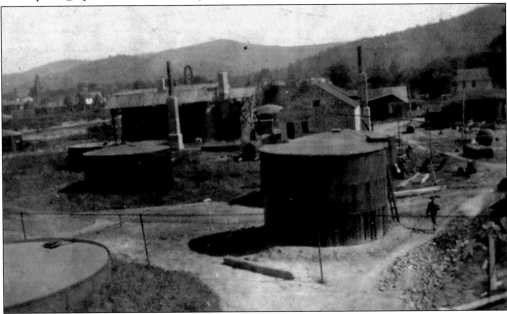

The Kendall Creek refinery was founded in 1881 by independent oilmen Eli Loomis, William Willis, and Robert Childs, who recognized the financial opportunity of an oil refinery in the heart of the Bradford field. Their growing enterprise had no official name; it was simply called Kendall Oil because of its location along the Kendall Creek. The name Kendall Refinery did not become official until 1913, when it was incorporated under that name.

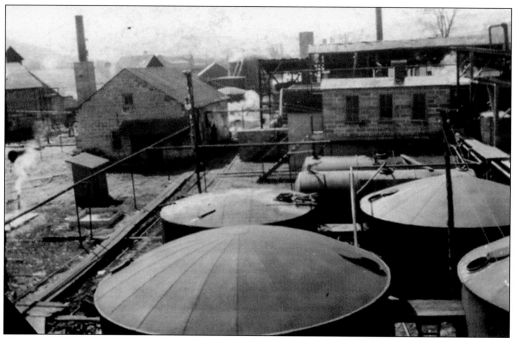

This small group of buildings was the heart of the new refinery in 1909. The workforce was small, just five men (two stillmen, one teamster, one roustabout, and one barrel maker), but the refinery managed to produce about 10 barrels of oil per day. A barrel of oil is equal to 42 gallons.

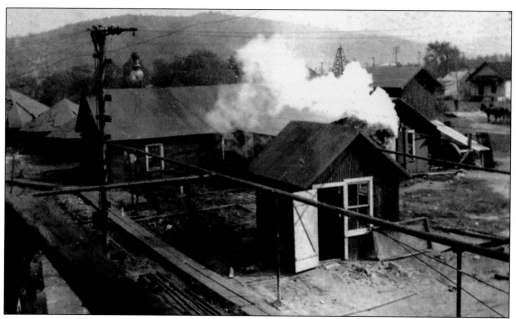

For unknown reasons, the firm of Loomis, Willis, and Childs did not prosper and was sold in March 1883 to satisfy its creditors. To add to their troubles, the three men were sued by a group of oil producers that placed a legal lien on the entire operation, two horses included. Willis left Bradford to homestead in Nebraska, Childs went to Montana for a few years to cattle ranch, and Loomis remained behind to face the Pennsylvania Supreme Court proceedings.

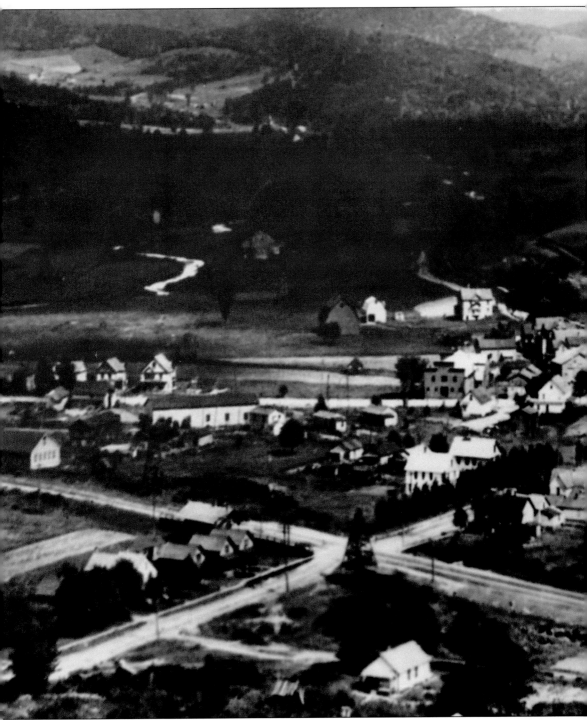

This early view of the Kendall Refinery was taken in 1905. For many years, it was believed that this photograph of the Kendall Creek/Tarport area showing the early beginnings of the Kendall Refinery was dated 1881, but new information has proven that it actually is much later. The refinery itself is located in the lower right-hand corner. On February 3, 1906, a 3:00 a.m. fire,

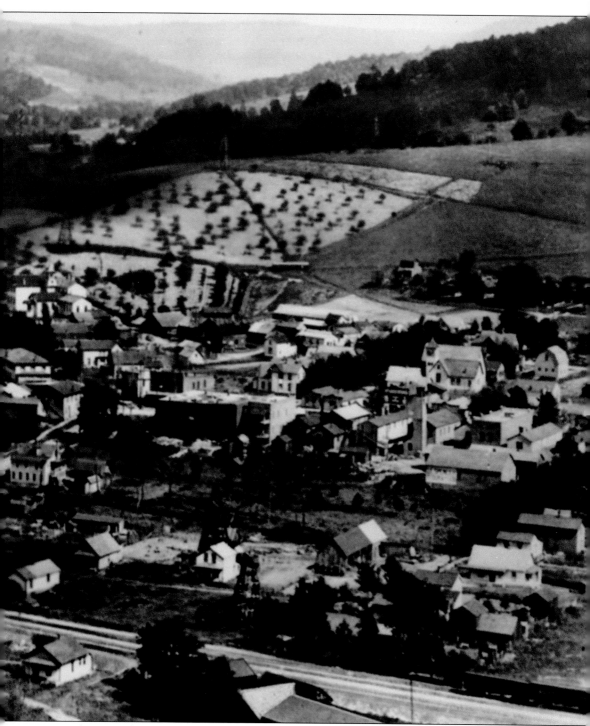
estimated to cost $10,000 in damages, broke out. Bradford City Fire Department, which sent three men and its fire engine steamer, "The City of Bradford," could not prevent the destruction of all the buildings except for the wax plant and the office building.

Wells drilled in the Pennsylvania and Ohio area have supplied the refinery with crude oil for the past 125 years. The oil in the Bradford area was discovered in an area of rocks known today as the Bradford Oil Field. These rocks are estimated to be 400 million years old, 200 million years before the dinosaurs walked the earth in a time called the Devonian Period. Crude oil is a fossil fuel, meaning that it was made naturally from decaying plants and animals living millions of years ago when Pennsylvania was covered with a shallow sea. When that marine life died, it settled to the sea floor and was covered with sand and mud. Over time, the mud and sand compacted into sedimentary rock and the deeply buried organic matter was subjected to great heat and pressure, which changed it into crude oil.

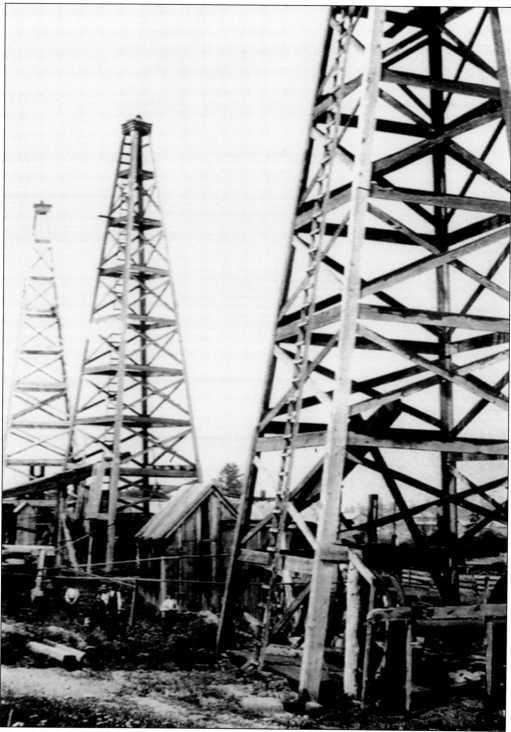
The Bradford Oil Field extends approximately 84,000 acres into two states, New York and Pennsylvania. Between 1871 and 1936, the field produced 352.7 million barrels of oil, making it, in its time, one of the top producing fields in the world.

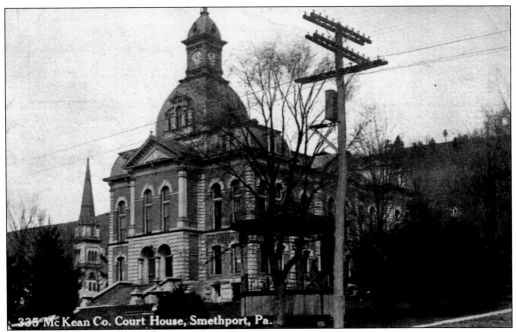

The McKean County Courthouse in Smethport was brand new in 1883 when a lien for unpaid debts was filed against Loomis, Willis, and Childs by a group of oil producers. The refinery, which had been assigned to Albert Short, a lawyer in Erie, Pennsylvania, was sold to Thede Barnsdall in 1883; later sold to his brother, Noel Barnsdall; and still later resold to Ross Hoffman of Penn Lubricating.

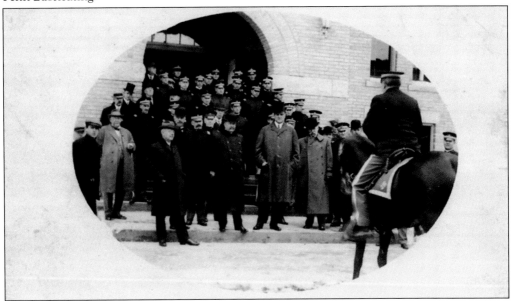

Born in 1843 in Clinton, New Jersey, Ross Hoffman came to Bradford in 1883, was mayor of Bradford, owned Hoffman Natural Gas, and was the president of Penn Lubricating Company, which owned two refineries in Bradford at the beginning of the 20th century—the Orient and the Kendall. In 1905, he built a wax plant at the Kendall site, discontinued the Orient, and chose Otto Koch as president. Hoffman, center front, wearing a bowler hat, is seen here on the steps of city hall.

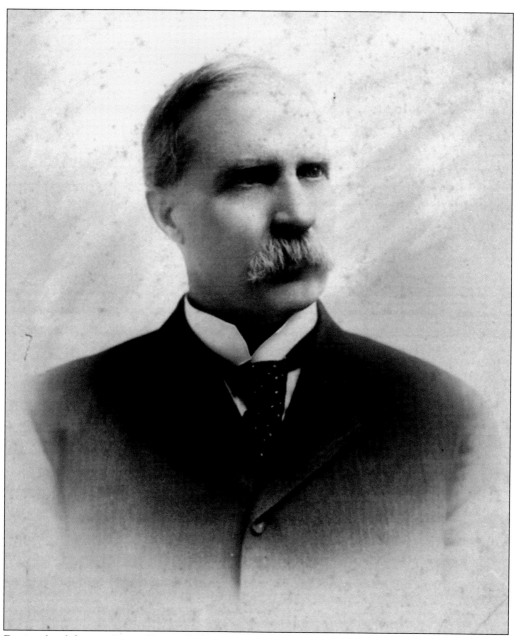

During his lifetime, Lewis Emery (1839–1924) was the most powerful oil man in Bradford and had a commanding hold on the oil industry throughout the region for decades. He even owned Edwin Drake's original drilling tools. He was one of the principal group of men who sued Kendall's founders, Loomis, Childs, and Willis, after their bankruptcy in 1883, taking the case all the way to the Pennsylvania Supreme Court. Emery was wealthy, political, and influential; however, his legal efforts to discredit and economically crush the Kendall Refinery (his own refinery's major competitor) took years and only partially succeeded. Emery eventually purchased his own refinery in 1887, but the Kendall Refinery steadfastly grew, and in 1935, nearly 50 years later, bought out its former competitor, Emery Manufacturing Company, and expanded its own operations on the site of Emery's refinery on Mill Street.

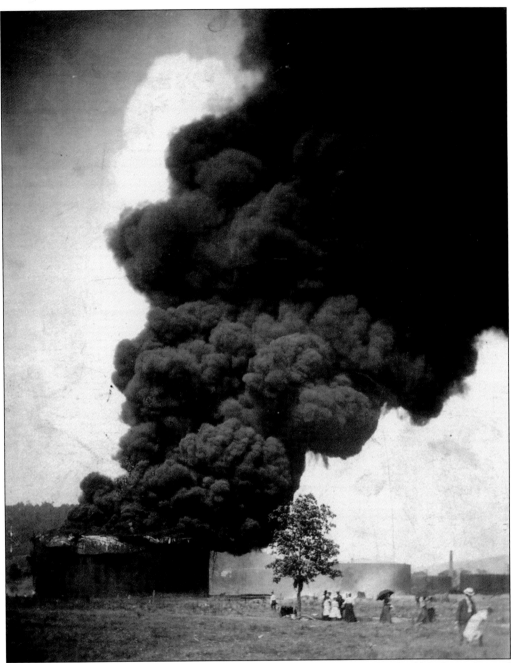

Whenever an oil storage tank caught fire, it created a tremendous cloud of black smoke and burned for days. This oil tank, containing 35,000 barrels of oil, caught fire when struck by lightening in 1906. The heat was so intense that it melted down the top rim of the tank. Sightseers have arrived by the East Main Street trolley to gaze at this amazing sight. If the sides of the tank had given way, or oil burned through, thousands of gallons of hot burning oil would have spilled over the ground, burning everything in their path. It is believed that a situation similar to this was the cause of the Kendall Refinery fire in February 1906.

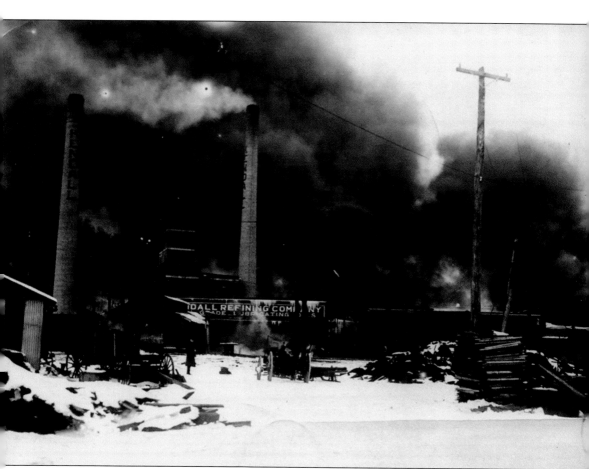

Although it appears that the Kendall Refinery is on fire in this 1909 photograph, the actual fire is taking place at an oil tank to the south, at the Emery Refinery on Mill Street. It is, however, a good depiction of what the Kendall fire looked like three years earlier. In February 1906, flames swept through the refinery, destroying all but the office and wax plant at a loss of $10,000 (nearly $270,000 in today's values). That fire, however, is considered the turning point in Kendall's history. The old equipment and buildings were replaced with modern equipment and new construction in brick, concrete, and steel, creating a fresh new start in a new century.

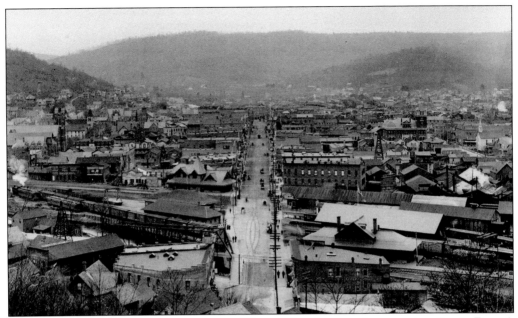

Bradford was growing at an amazing rate. Three refineries were in operation: Lewis Emery's refinery; the Orient refinery, located off East Main Street; and the Kendall Refinery, owned at the time by Penn Lubricating. There were only a handful of cars to drive on the mostly unpaved roads, but times were changing. In 1903, there were six cars registered in the city; by 1920, there were 1,250. Times were changing, indeed.

This oil derrick was located somewhere in the Bradford field. The year that the refinery was established, 1881, was a peak year for the Bradford field, which produced 83 percent of the country's entire crude oil output and 77 percent of all the crude oil produced in the world. Another 11,800 wells were drilled in 1882, and many men became millionaires almost overnight.

Two
SUNNY DAYS AHEAD

In the first 25 years of its existence, Kendall Refining went bankrupt, was sold three times, and suffered a devastating fire. No wonder Otto Koch hoped for better times ahead as the refinery entered the early decades of the 1900s. An example of his faith in the future can be seen in this photograph of the barrel house in 1909. Rebuilt after the fire of 1906, the barrel house was the main distribution point for filling barrels with oil and kerosene. Sunshine Oil, which can be seen clearly marked on the barrels, was the brand name chosen by Koch for Kendall oil in the decade following the refinery fire of 1906.

Otto Koch, seen here in this c. 1918 photograph, was born in 1866 and is generally considered to be the catalyst behind Kendall's recovery from the devastating refinery fire in 1906. He was born in Chautauqua County, the son of a Civil War veteran, and attended Bryant and Stratton Business College in Buffalo. He successfully founded a funeral undertaking business in Bradford in the 1890s, but quit that enterprise in 1905 at the age of 39 to accept the management of Kendall Refining Company. As director, secretary-treasurer, and manager, his firm guidance brought the nearly ruined refinery back from the edge of financial disaster. Later it was said that he "guided Kendall through the deep depression without a reduction in personnel, without debt, without a deficit or the omission of a dividend in any of those years."

Otto Koch and his brother Louis founded this undertaking parlor in the early 1890s, but Otto was persuaded to take over the operation of Kendall in late 1905, just before the fire of February 2, 1906. Realizing that his future lay with the refinery, he sold his interests in the mortuary to Louis in 1929. This building stands on the corner of South Avenue and East Corydon Streets and is still used as a funeral home 100 years later.

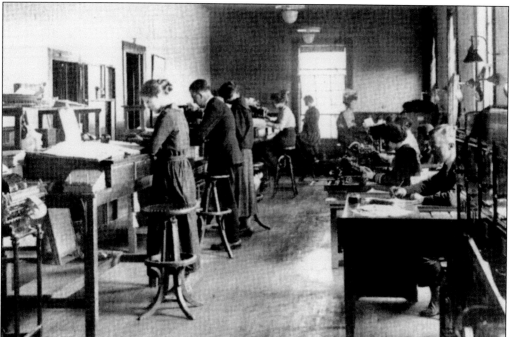

Office workers pose for this photograph inside the refinery office building around 1910. Keeping accurate accounts was very important to the refinery, which had almost been destroyed by fire just four years before. Tall ledger desks and stools kept the bookkeepers at their jobs.

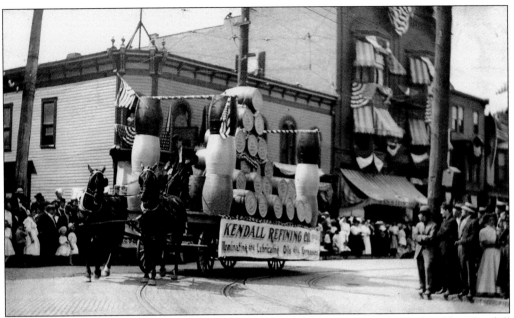

Otto Koch was also a community leader and supported public events and parades. This Kendall Refining Company float is rounding the corner of Main and Mechanic Streets during the 1909 Old Home Days parade in Bradford. Thousands of people, many of whom would remember this float and the Kendall name when buying oil in the years to come, attended the celebration held the week of August 12.

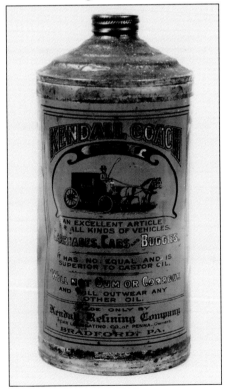

An early Kendall oil product was coach oil, considered excellent oil for all kinds of vehicles, carriages, cabs, and buggies. With only six automobiles registered in Bradford in the early 1900s, Kendall's main product was heating oil.

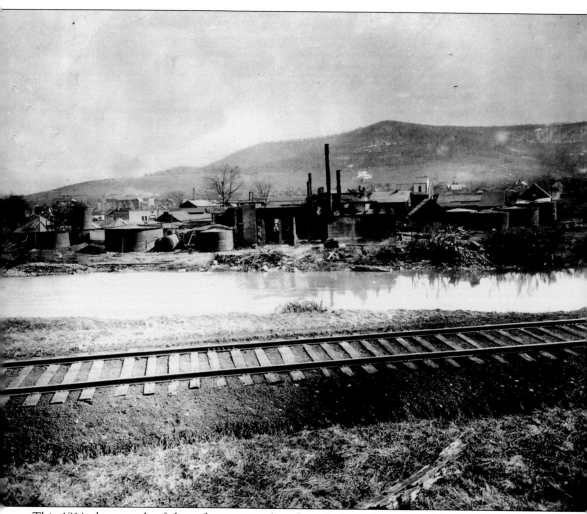

This 1914 photograph of the refinery was taken from Jackson Avenue and looks east across a rather large ditch that stood beside the refinery for many years. This ditch is often referred to in early deeds as one of the property boundaries, as was the Tunungawant Creek (commonly referred to as Tuna Creek). In the early 20th century, a slight ridge of ground about two feet above the level of the creek ran through the middle of the refinery (basically, where today's main access road lies), dividing the refinery into two sections. This elevation was designed to be utilized in case of a fire emergency, when a downhill gravity flow would cause burning oil to be carried away from the main refinery in two different directions through gutters (one wood, one cement) and then carried into the creek. While such ingenuity would have prevented a disastrous fire in 1914, by today's environmental standards such actions would be unthinkable.

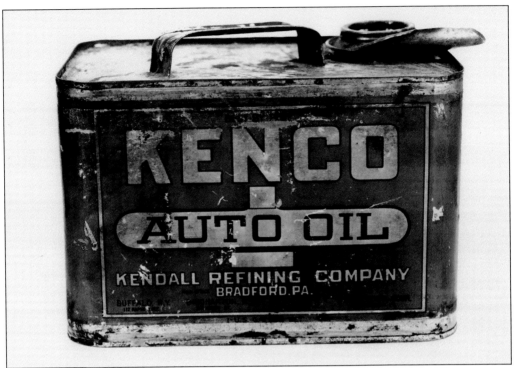

Kenco, an automobile oil brand formulated by Kendall Refining Company in 1923, came in a rectangular can so that it could fit more easily on the running boards of cars. This oil was made to flow at freezing temperatures for instant startup and lubrication.

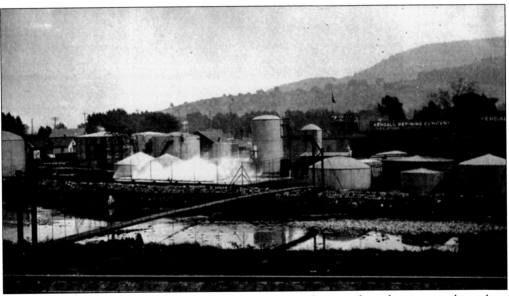

In the 1920s, Kendall ran a contest open to any amateur photographer who competed to take a photograph of the refinery. James E. Shaw, a Kendall employee, submitted this refinery photograph. It is not known if it was the winner of the contest, but it is the only one that still exists.

Printed as early as 1921, these handy pocket guides were packed with all sorts of information: a daily calendar, of course, and useful information that might include lists of automobiles, types of Kendall products, lists of past sports teams, travel distances, monetary exchanges, weather signal interpretation, holidays, and more.

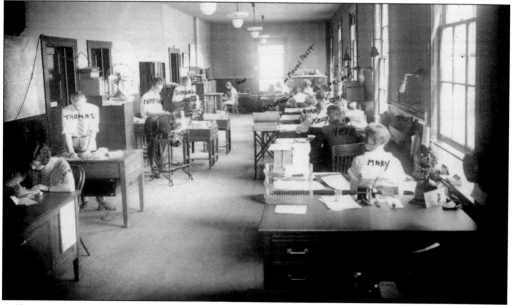

Office workers are at work inside the refinery office building around 1925. As Kendall Refining became more profitable, adding machines, typewriters, account books, ledgers, pencils, and pens made up the modern office, where all the men wore white shirts and ties, and women wore dresses. Jobs for women at Kendall were strictly clerical until the days of World War II, when a shortage of male refinery workers convinced Kendall to hire women in other positions.

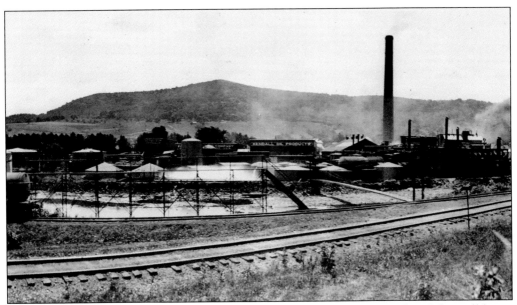

This 1922 photograph shows an oil refinery that is very different from today. Oil is still being refined by the use of batch stills, but by 1923, a Dubbs cracking unit was installed, and in 1929, the first crude tower, the Foster Wheeler, was in place. The refinery has always strived to keep pace with new technology and maintains that goal even today.

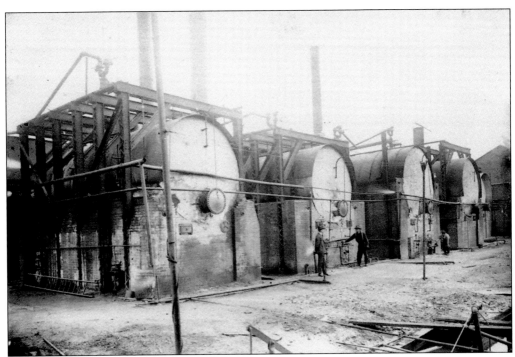

Batch stills, sometimes called "cheese boxes," were used to separate crude oil into useful products. Generally these stills were heated with coal and could distill varying amounts of crude per day.

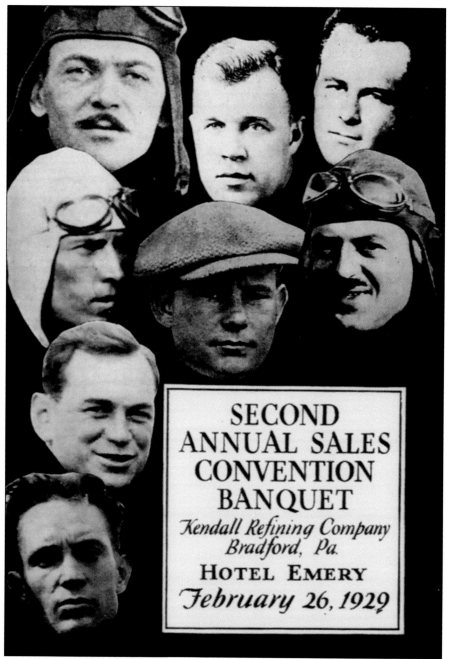

This Second Annual Sales Convention Banquet booklet from the Kendall Refining Company is dated February 26, 1929. The men featured on the front cover of this booklet are not Kendall employees but are well-known aviators of the time. All eight men had participated in the National Air Races held the summer before, using Kendall oil. Harri Emery and Parker Cramer, both Bradford natives and pilots, are pictured here. Otto Koch was, in particular, a huge fan of air flight and encouraged Kendall to create special motor oil designed for the aviation industry. The convention was held at the newly opened Emery Hotel, where a special meal, including Kendall Salad with "2,000 Mile" oil dressing, was served.

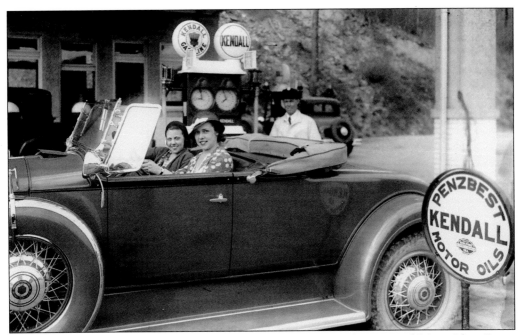

"Fill 'er up with Penzbest from Kendall," Elizabeth Fesenmeyer, driving, and Mary Alice Evans seem to be saying to the uniformed attendant in 1932. They probably would not have dreamed of pumping their own gas and indeed, it was illegal to do so until Pennsylvania state law was changed on November 1, 1971. Today self-service gas stations are the norm.

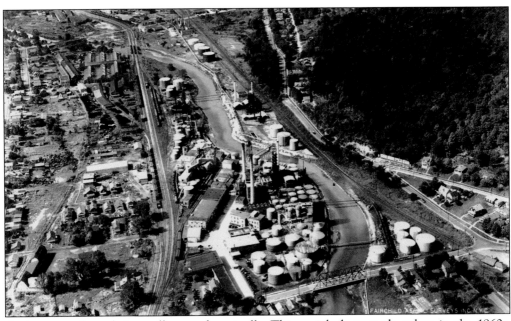

A river runs through it—well, a creek, actually. This aerial photograph, taken in the 1960s, clearly shows Tuna Creek as it flows through and along the eastern side of the refinery. The refinery is not only the longest continuously operating refinery in the United States, it has been located at the same site, along the banks of the Tuna Creek, for 125 years.

In 1928, Kendall invented the 2,000 Mile Motor Oil, astounding the driving public whose cars needed oil every 500 miles to run their best. Although the exact date of origin is unknown, this famous symbol dates from that era and became one of the best-known icons in the automotive world. The hand, holding up two fingers, represents the 2,000 Mile Motor Oil innovation.

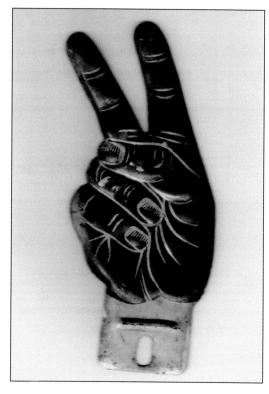

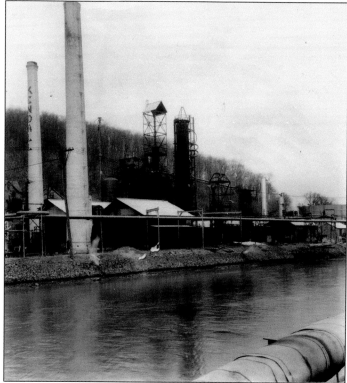

The Dubbs unit, shown here in 1923, no longer exists. The Dubbs process made possible the thermal cracking of heavy hydrocarbons to gasoline. The higher the cracking point, the higher the octane. Invented by Jesse A. Dubbs in 1919, the unit was put into production at the refinery in 1923. Dubbs, a Venango County native, patented this process while working for Universal Oil Products in California.

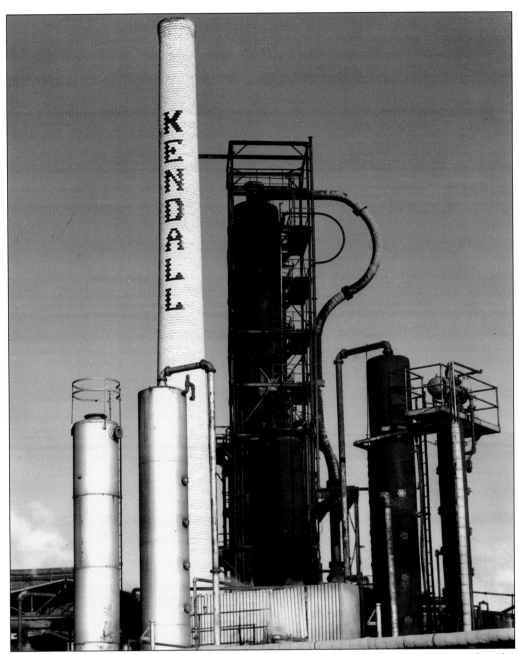

The erection of a new, modern crude fractionation unit at the refinery was announced at the annual Kendall sales convention on February 27, 1929. Completion was promised by July 15, 1929, but it was onstream early that summer. The new unit had a rated capacity of 3,500 barrels per day. The Foster Wheeler unit, named after the company that built it, remained in operation until 1985, when it was replaced with the current unit now in operation. "It consisted of two principal parts: the heating unit and the fractionating tower where the various boiling point fractions are separated into their component parts. These components are naphtha, kerosene, gas oil, wax distillate, and a resid cylinder stock. The heating unit is designed for burning gas or fuel oil."

Moving this large section of the Foster Wheeler unit into the refinery in the summer of 1929 was a delicate job, since the main section was 105 feet in length.

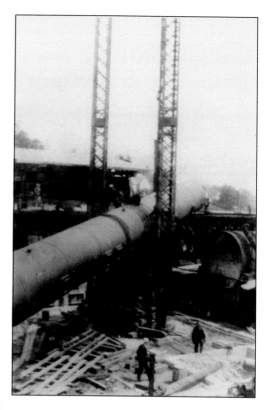

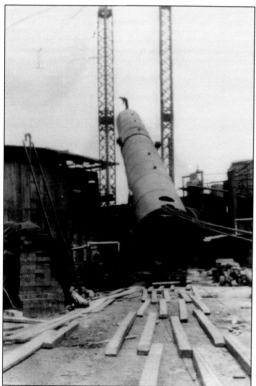

Maneuvering the huge central tower into place without damage or injury took experience and nerve. Notice the man standing on the top edge watching as the tower is skidded along boards. The local newspaper wrote, "the unit is a most compact and efficient piece of equipment, only occupying ground space to the extent of 105 feet by 35 feet." And, it added, only three men are required to operate the unit.

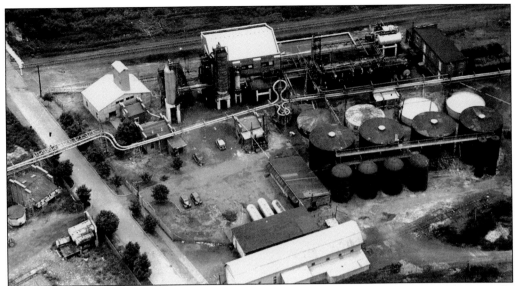

Lewis Emery bought this refining operation, established in 1884 in an area that would eventually become Mill Street, from John Haggarty in 1887. Emery's refinery was a powerful competitor to Kendall operations, but Emery's death in 1924 and a series of several fires, including the destruction of their new Stevens cracking unit in 1928, caused the company to be sold to South Penn Oil in 1928. A few years later, Kendall Oil purchased the old Emery refinery from South Penn and expanded its own operations.

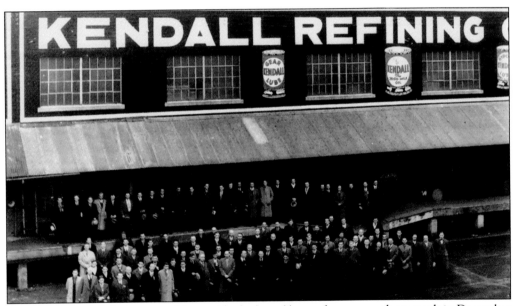

A group of Kendall dealers assemble outside the barrel house for a group photograph in December 1936. The dealers, who hailed from all over the eastern seaboard, were invited to the grand start-up of the new dewaxing and deresining unit. A tour of the plant and dinner at the Emery Hotel followed a busy day of meetings. Construction of the new solvent dewaxing unit, in addition to a new boiler house and new electrical equipment, was announced on April 29, 1936; the total cost was estimated to be $1.2 million (roughly $16 million in today's economy).

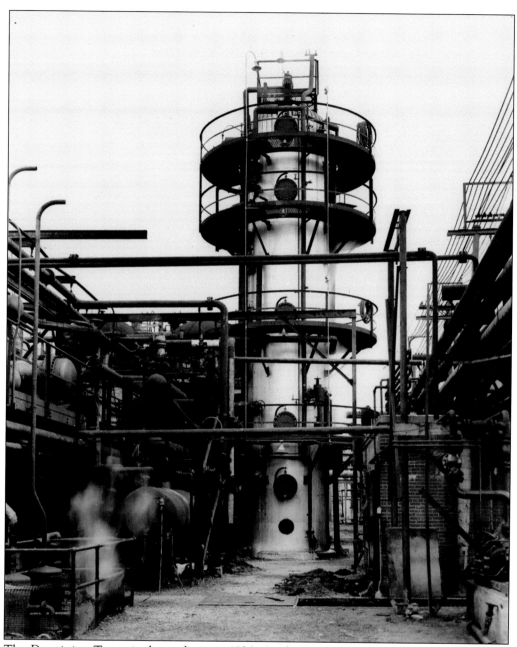

The Deresining Tower is shown here in 1936. At the Dewaxing and Deresining (D and D) Unit, cylinder stock was first dewaxed using chilled propane, and then heated propane was used for deresining. Dewaxing allows the finished oil to flow at low temperatures, while deresining improves the characteristics of the finished oil by the removal of aromatic compounds. This tower was the first such unit to be erected in Pennsylvania when built in 1936.

PHENOL

DANGER! RAPIDLY ABSORBED THROUGH SKIN CAUSES SEVERE BURNS

☠ — **POISON** — ☠

DO NOT GET ON SKIN OR IN EYES.
AVOID BREATHING VAPOR.
DO NOT TAKE INTERNALLY.
IN CASE OF CONTACT, IMMEDIATELY FLUSH SKIN OR EYES WITH PLENTY OF WATER FOR AT LEAST 15 MINUTES, FOR EYES, GET MEDICAL ATTENTION. REMOVE AND WASH CLOTHING BEFORE RE-USE.

The phenol warning sign is seen from outside the phenol plant in the 1930s. The phenol plant was the first one in Pennsylvania. Oil that had been dewaxed passed through the phenol process, where the oil was further refined to improve the performance over a wide range of temperatures. In the early 1980s, this unit was converted to an N-methylpyrrolidine extraction unit.

The D and D Unit was built in 1936 as the first propane dewaxing and deresining plant installed in Pennsylvania and the fourth such unit in the country. The process removed petrolatum and resins from cylinder stock at a temperature of 40 degrees below zero. The process was eventually replaced by the methyl ethyl ketone (MEK) dewaxing unit and the residual oil supercritical extraction (ROSE) deresining units, which are still in operation today.

Three
WORKING HARD FOR TOMORROW

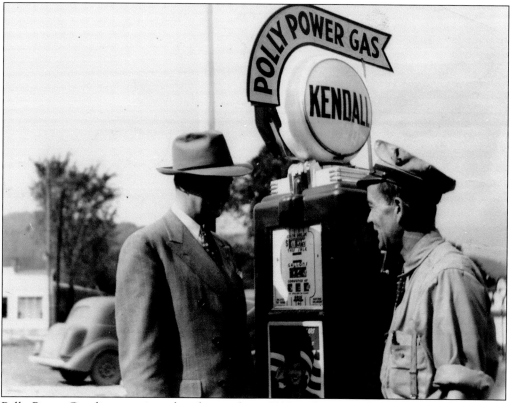

Polly Power Gasoline was introduced as early as 1939 and remained an important marketing slogan for over 30 years. This photograph, which dates from the 1940s, shows an old-style gas pump with a patriotic poster of a woman in the military, encouraging drivers to "enlist your dollars if you cannot enlist yourself." Sam Brill is standing at left in front of the pump.

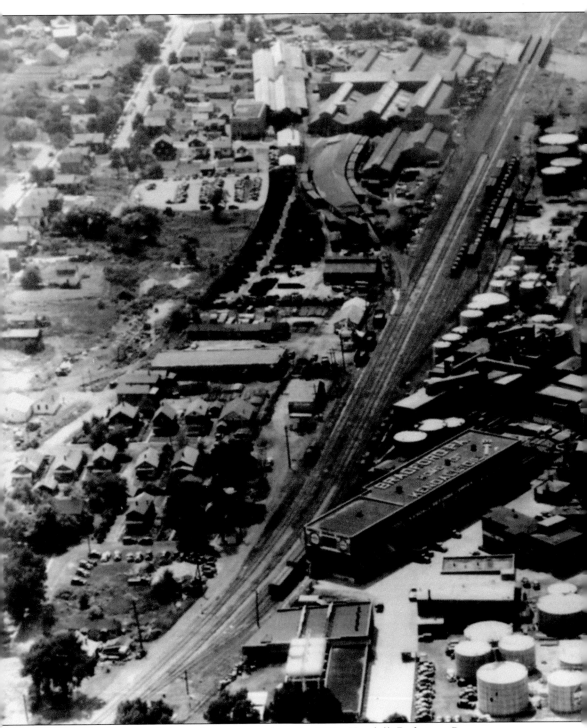

This aerial view of the refinery was taken in 1937. Kendall Refining Company was very progressive and was always ready to upgrade and improve its operations by installing a Dubbs cracking unit in 1923, a Foster Wheeler crude unit in 1929, a propane deresining and dewaxing unit (fourth one built in the country) in 1936, and a phenol unit, as well as announcing plans

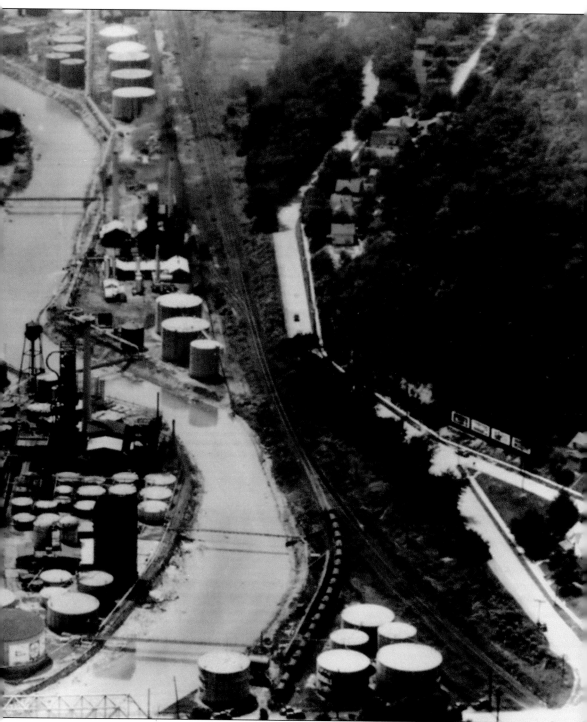
for a mechanical laboratory (later automotive laboratory), a research laboratory, and a quality control laboratory. There were nearly 650 employees working at Kendall when the hourly wage for common laborers was raised to 57¢ per hour in 1937.

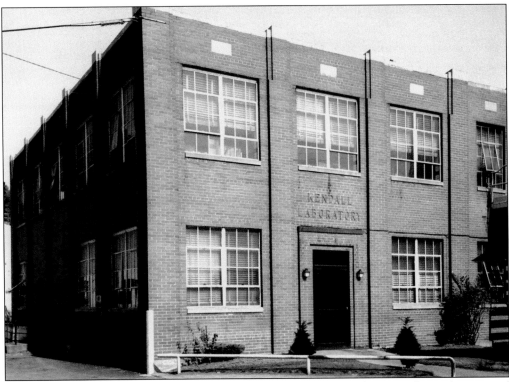
Located in the main part of the refinery, the Kendall Laboratory is home to the quality control lab. It was built in the late 1930s and looks very much the same today.

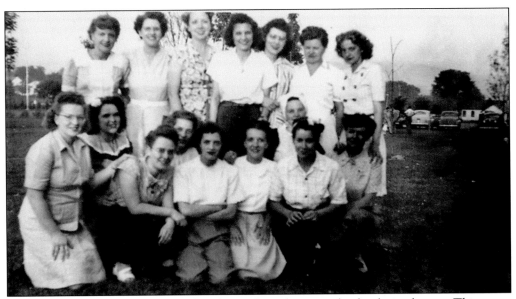
During World War II, women were hired to replace the men who fought in the war. This group of women all worked in the quality control laboratory in 1942. Never expecting women to be employed inside a refinery, Kendall had to adjust to a feminine workforce and remodeled the quality control laboratory building to provide women's restrooms.

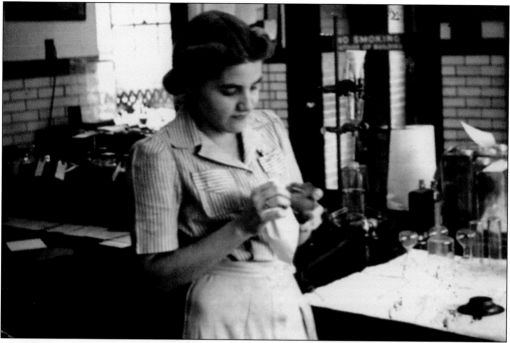
Kay Harvey, one of the quality control laboratory workers, is testing viscosity.

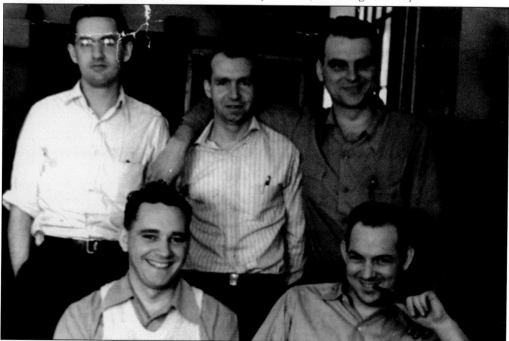
Some men were deferred from the military draft of World War II because of their employment in a defense-related industry such as an oil refinery. Kendall supplied gasoline, oil, lubricants, and other products essential to military operations. These five men worked in the research laboratory during the war; from left to right are (first row) Otto Koch Jr. and Dick Gray; (second row) Al Smith, John Brenneman, and Dick Crumley.

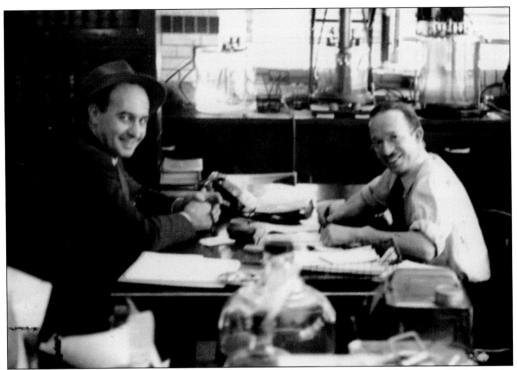

Frankie Waldo was the man in charge of running the quality control laboratory. He is shown at his desk, talking with a visiting army inspector. In 1942, the Bradford field produced 15,532,473 barrels of crude in an effort to meet the tremendous military demand.

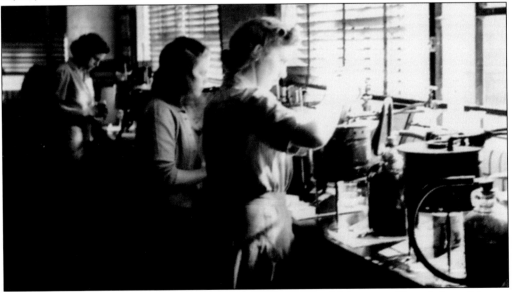

These women are doing viscosity testing in the quality control laboratory. From left to right are Doris Kinsell, Mary Boyle, and Gerry Frick Cookson. Cookson, who went to work for Kendall directly out of high school, lived in Cyclone, but because of gas rationing during the war (and the 12-mile distance to home), she boarded during the week with another girl on East Main Street and only went home on weekends.

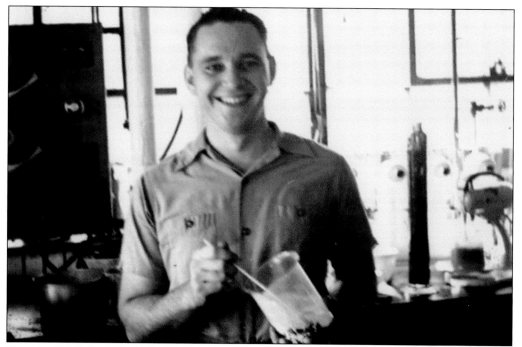

Born in 1914, Otto Koch Jr. was the son of Otto Koch Sr., who had so skillfully brought the refinery out of ruins after the fire of 1906. Working in the quality control laboratory, he later became a member of Kendall's board of directors.

Alyse Hample Rosen, one of the young girls employed in the quality control laboratory during the war years, is shown wearing the official uniform required by Kendall. *News Bits*, an employee newsletter in 1945, wrote "the most striking impression on entering the Lab is the sight of girls in slacks running quality controls tests."

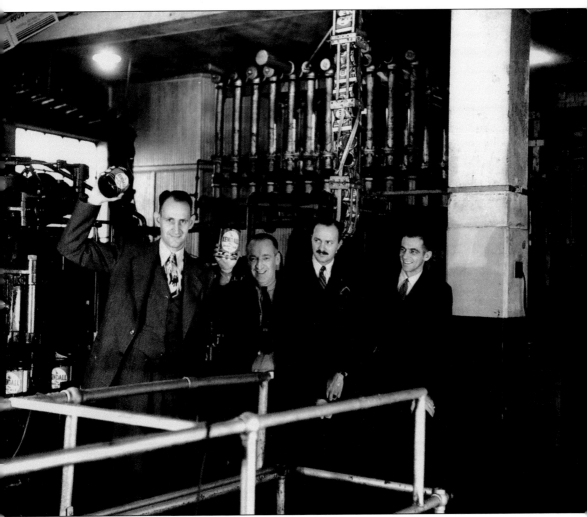

As part of the war effort in the 1940s, the metal used in motor oilcans was diverted to military use and the refinery switched back to using glass containers. In 1945, as World War II drew to an end, and with the consent of the War Department, the refinery was once again allowed to use tin quart containers for Kendall 2,000 Mile Motor Oil. An employee newsletter called *News Bits*, published during the war, reported that the last glass jar was filled on Friday, October 12, 1945, about 3:00 p.m. "It seems rather quiet, now, no glass breaking and rattling, and everyone seems in a better mood," wrote Clarence Masten, an employee in the barrel house. Here, from left to right, Bill Knapp, Waddy Moffatt, Russ Keck, and Hal Osborne seem elated to be using metal cans once again.

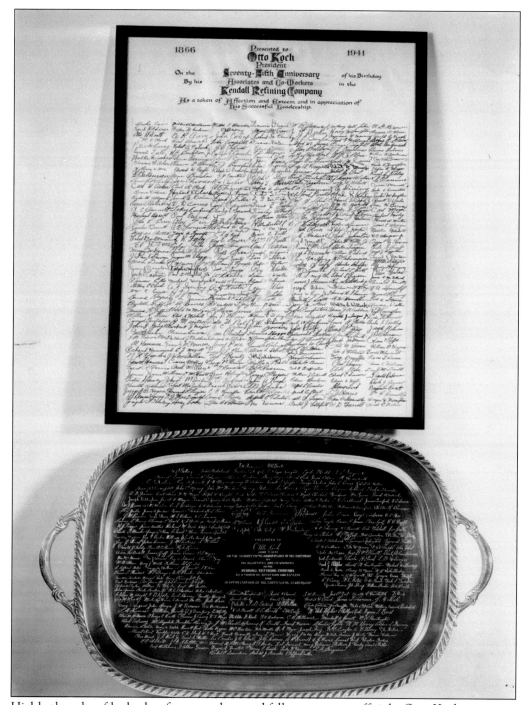

Highly thought of by both refinery workers and fellow company officials, Otto Koch was given this sterling silver engraved tray on the occasion of his 75th birthday in 1946, "as a token of affection and esteem and in appreciation of his successful leadership." The signature of every employee was engraved on the tray. Koch died two years later on October 12, 1948.

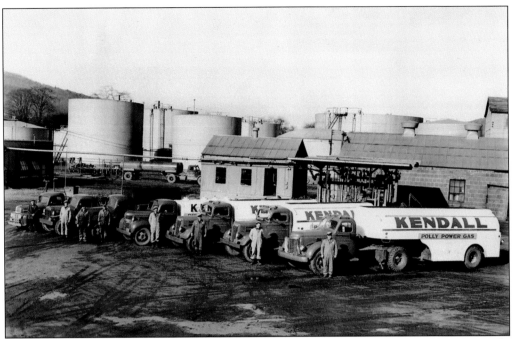

The Kendall fleet of oil tankers is shown at the Foster Brook bulk station. Notice the "Polly Power Gas" sign on the tanker at right. Polly Power was used as an advertising slogan from the late 1930s until the mid-1970s.

Ever wonder how they move those tanks? This tank is being very carefully moved to a new location in this photograph dated March 27, 1949.

This photograph of the automotive laboratory at Mill Street was taken on March 4, 1969. Built in 1940, the new mechanical laboratory tested motor oil in automotive engines under conditions resembling those found in road use. It was renamed the automotive laboratory in 1945. In October 1970, the automotive laboratory and the research laboratory at Foster Brook were combined and moved into a new research and development laboratory and sales building on North Kendall Avenue.

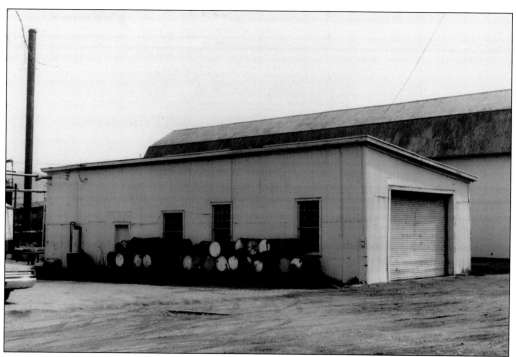

The garage for the automotive laboratory was located on Mill Street. A portion of this building can be seen at the rear of the automotive laboratory building in the above photograph.

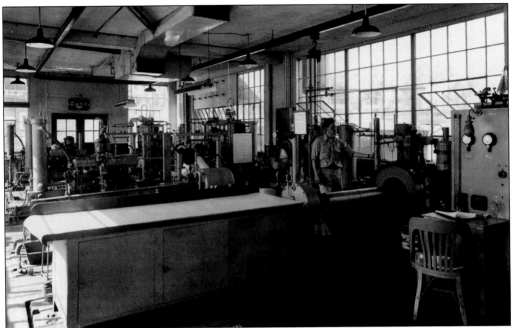

Employees, skilled in operating different equipment, performed many tests in the new automotive laboratory. This employee is monitoring a water force dynameter.

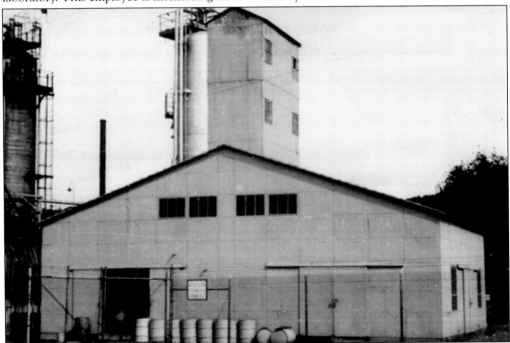

The processing laboratory on Mill Street is shown here in 1937. Small amounts of oils, lubricants, and greases were produced using the latest refining processes and were tested under simulated conditions. The products were thoroughly checked by road and engine tests. This unit eventually became obsolete when the new mechanical laboratory (later renamed the automotive laboratory) was built in 1940.

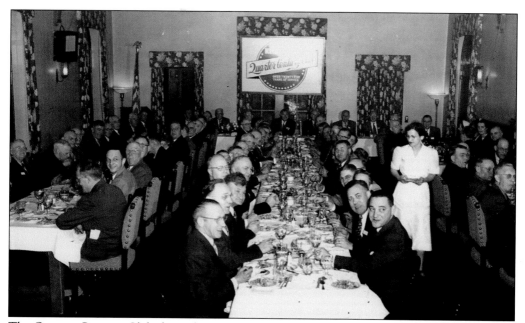

The Quarter Century Club, formed in 1951, honored employees who had worked at the refinery for 25 years or more. The inaugural dinner was held on February 24, 1951, at the Pennhills Club. President J. B. Fisher gave a short speech, followed by a presentation of service awards and recognition of employees. The oldest charter member was Fransue Day, who had first worked at the refinery in 1903.

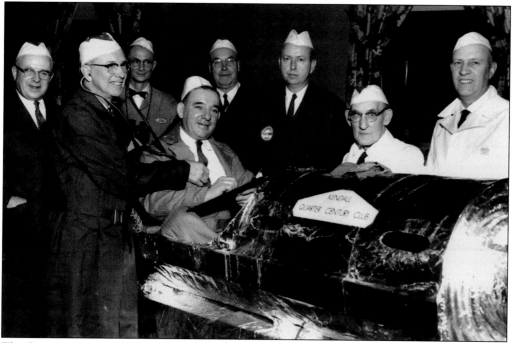

The Quarter Century Club members had a lot of fun at their dinners; in February 1958, employees Pete Shoup, John Brenneman, Ed Carlson, and others gather around Glen "Beef" Witchen, in an aluminum-sided race car. The Quarter Century Club is still active with 247 members.

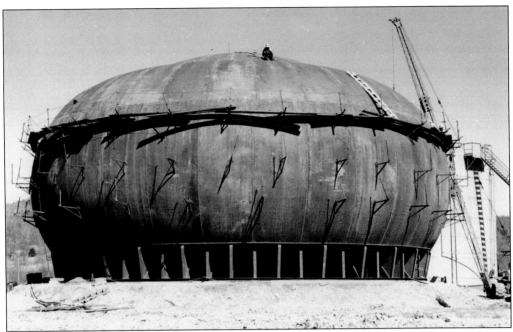

Shown here is a Hortonspheroid tank at the Foster Brook bulk plant. Invented in 1923 by the Chicago Bridge and Iron Company and named for its founder, Horace E. Horton, spherical pressure tanks are used worldwide for the storage of volatile liquids and gases. This photograph, dated April 4, 1951, shows this unique tank under construction.

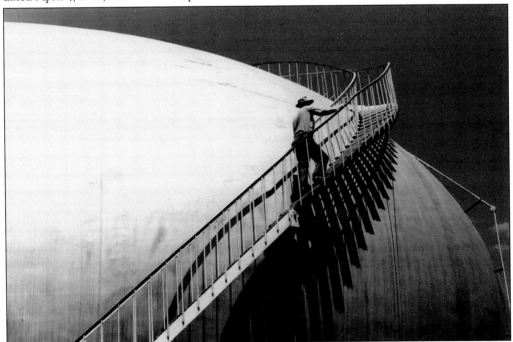

The finished Hortonspheroid is shown here in July 1953. Such spherical tanks proved impractical for heavy Pennsylvania crude oil. There are 375 storage tanks at the refinery; this is the only Hortonspheroid ever built here.

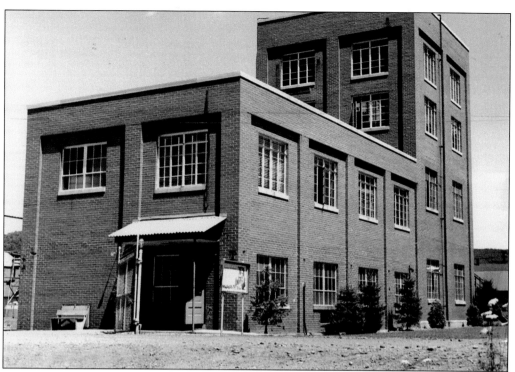

Built in the 1940s, this building was demolished when the research laboratory at Foster Brook and the automotive laboratory at Mill Street were combined and moved into a new facility on North Kendall Avenue.

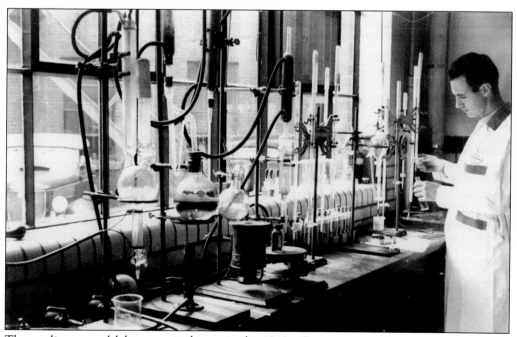

The quality control laboratory is shown in the 1940s. Constant testing is necessary to assure superior performance of refinery products.

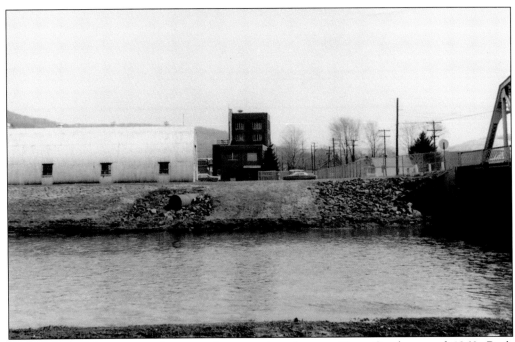

The research laboratory and quonset hut are viewed across Tuna Creek around 1968. Both structures are now gone; the Foster Brook exit ramp of U.S. Route 219 passes very close to this location.

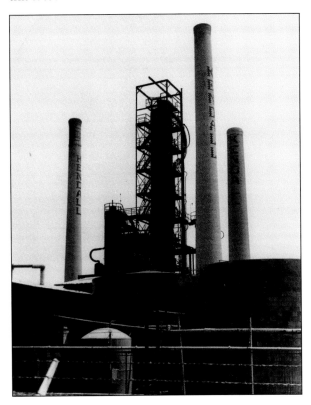

The old Foster Wheeler crude unit, with its challenging multilevel staircase, is surrounded by three smokestacks at the Kendall Refinery in this photograph dated July 24, 1955. Today all three are gone. American Refining Group proudly painted its own initials—ARG—on the one remaining stack at the boiler house following the purchase of Witco Corporation's Bradford refinery in 1997.

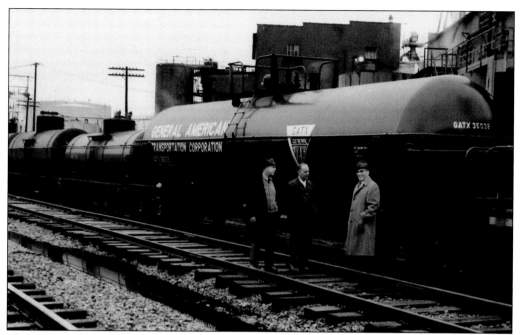

This 54-foot oil tanker was one of the largest tanks on rails in the world when it visited Bradford in 1959. It had a 10-foot diameter and could hold 20,000 gallons of oil, twice the capacity of a standard tanker of its day. Whitey Frampton, Julius Swanson, and George Keller (shown from left to right) seem impressed by its size.

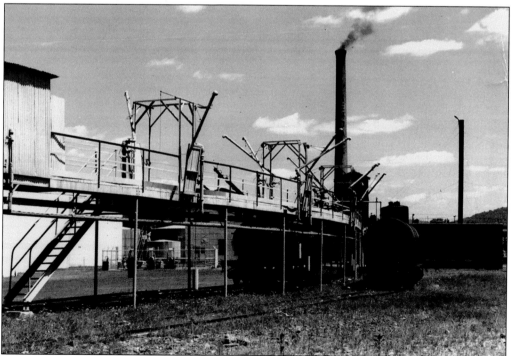

This railroad tank car is being filled at the Foster Brook plant at the old crude rack. No longer in existence, a modern version can fill about four railcars at the same time.

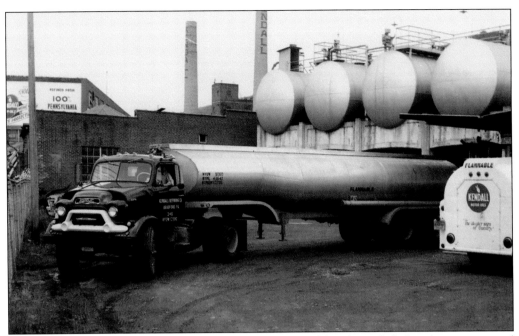

Driving a tank truck with almost 6,000 gallons of flammable oil is a skill that few experienced drivers acquired. Bill Broughton is leaving the bulk plant on North Kendall Avenue in this 1960s photograph.

Employees who suggested time-saving changes, or improved an existing job, were often rewarded with a small monetary thank-you. James Ruth, left, who worked in the barrel house, figured out a way to make crimping barrel lids more efficient. Here he demonstrates his award-winning idea on the crimping tool at the barrel house to Guy Whipple, at right, and an unknown employee on May 2, 1960.

As new processes evolved, equipment such as these two smokestacks became obsolete and were removed. Theses stacks were for the old boiler house—the multilevel building in the center of the photograph. These two stacks were taken down in August 1973. This photograph shows the stack in the background about half demolished.

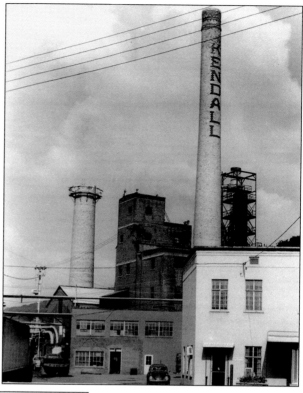

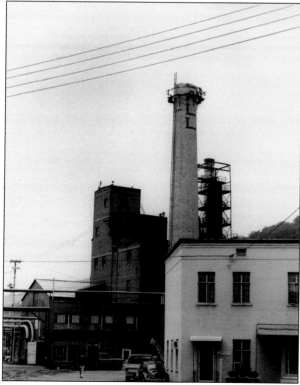

Work continues on knocking down the stacks. The second stack is dismantled all the way down to the "all" in Kendall.

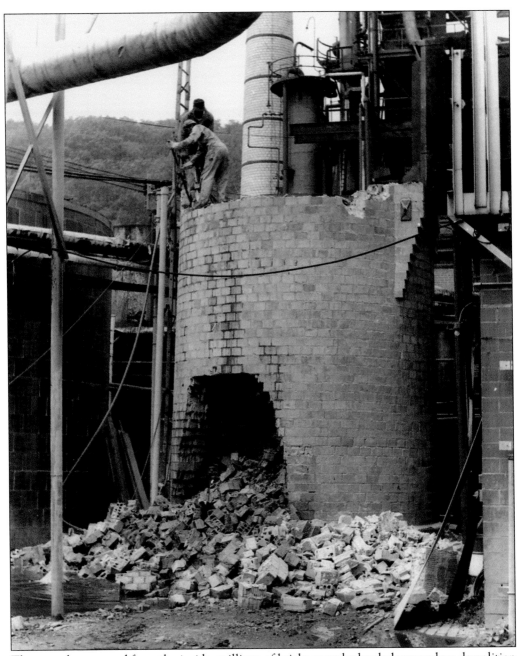

These stacks are razed from the inside; millions of bricks must be hauled away when demolition is complete. Today only one smokestack remains, near the Mill Street portion of the refinery. It has had three different names painted on it at various times over the years: Emery Mfg., Kendall, and now ARG.

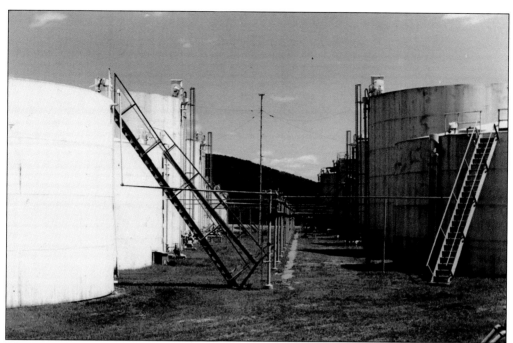
These gasoline storage tanks at Foster Brook are shown in 1953. Properly maintained, a tank can be utilized for decades.

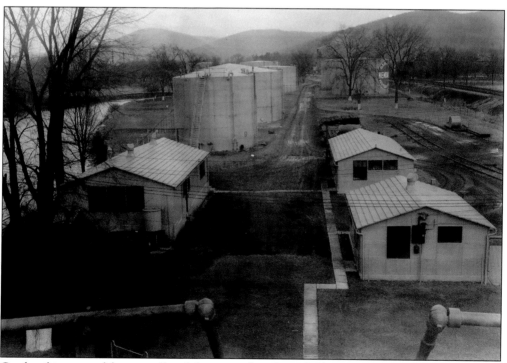
Crude oil is pumped from a well and then transferred to a field storage tank or "tank farm." This small tank farm was located at Foster Brook. Ten of these large tanks could supply enough crude oil to supply the refinery for about 10 weeks in 1941.

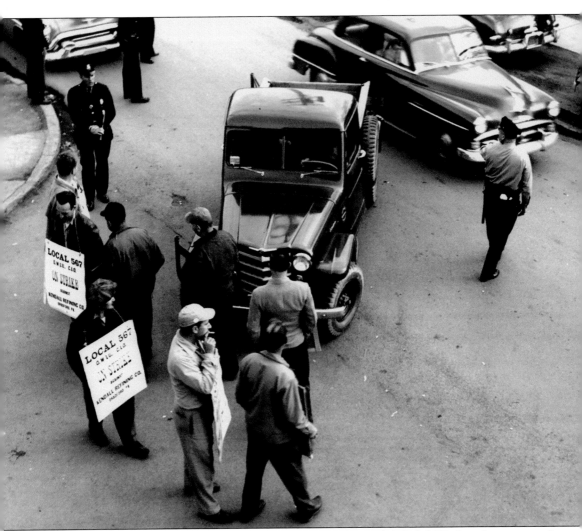

A long strike between Kendall Refining Company and Local 567 Oil Workers International Union captured the attention of Bradford for more than five months in 1954. Union workers went on strike in late January when the union and Kendall could not agree on a new employment contract, and picket lines were set up on North Kendall Avenue. A court order stated that only three pickets at any one time were allowed at the gates; no intimidation, threats, force, or abusive language would be allowed; and pickets must step aside to allow all traffic in and out of the refinery. At times the strike action turned angry, with broken windows, strikebreakers, accusations, and bitter feelings. The strike finally ended in early summer.

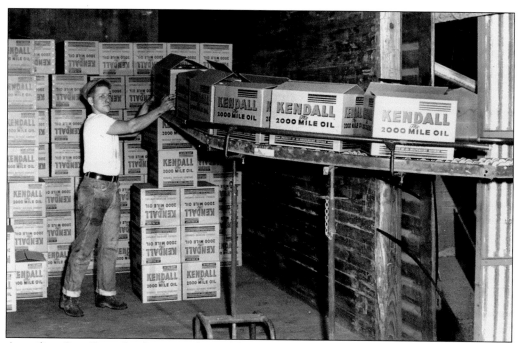

A smiling Jim Gates loads cases of Kendall oil onto the after conveyor belt at the shipping department on August 28, 1951.

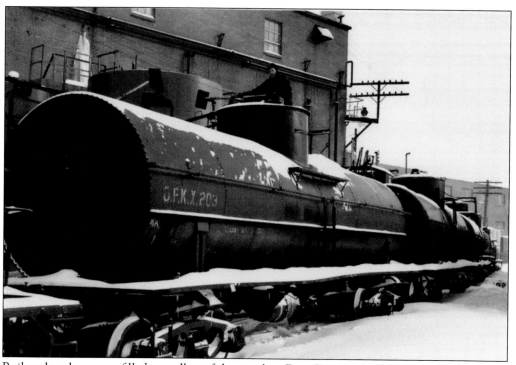

Railroad tank cars are filled regardless of the weather. Don Curtin is loading several railroad cars on this snowy day in February 1958.

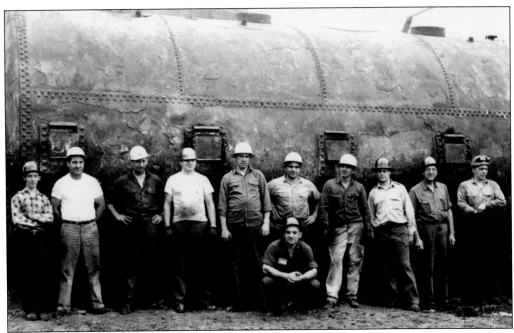

These refinery employees had the task of dismantling one of the old batch stills in July 1961. From left to right are unidentified, Marty McLaughlin, Harold McLaughlin, Leon Potts, unidentified, unidentified, John Sepula, unidentified, Hap Beck, Eugene "Pete" Frampton, and Beef Witchen, kneeling.

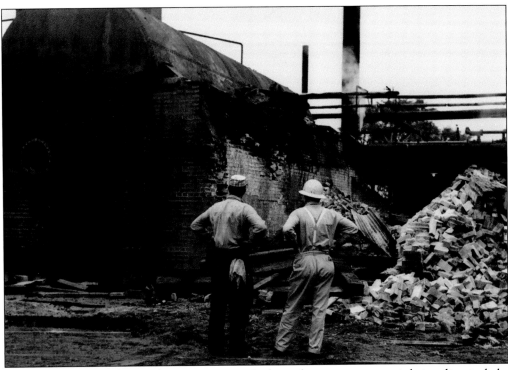

Batch stills were very large. These men are overlooking the progress as one is being dismantled.

Four
Progress in Peacetime

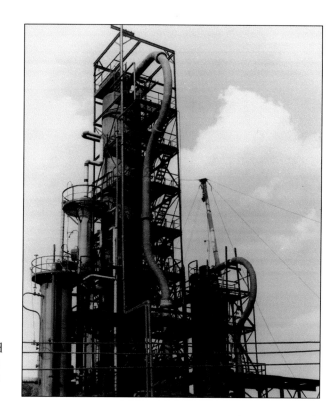

Here is an excellent view of the old Foster Wheeler crude tower, which shows an added side stripper to the main unit.

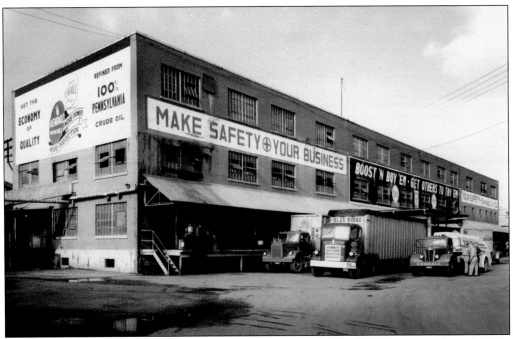

These trucks are being loaded at the barrel house on North Kendall Avenue on June 6, 1952. The smaller white tanker truck was driven by Don Highgates, and later Albert Jones.

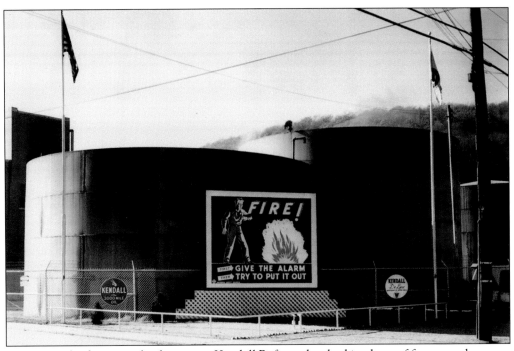

Fire in an oil refinery can be disastrous. Kendall Refinery has had its share of fires over the years, so all employees are diligent in fire prevention. This large billboard in the mid-1970s reminded all employees to be constantly on guard.

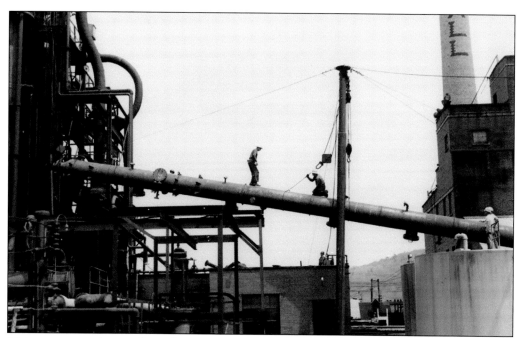

Maintenance and upgrading of equipment is an ongoing process as new technology advances the efficiency of oil refining. Here, in May 1960, a new section of the Foster Wheeler crude tower is being moved into position. Its long length and weight make maneuvering it through the refinery a difficult task.

Confined by a creek on one side and a railroad on the other, when any large piece of equipment is moved through the refinery it makes for some tricky maneuvering. The potential for injury to employees and damage to existing buildings or other equipment is always present, and such events require very careful planning.

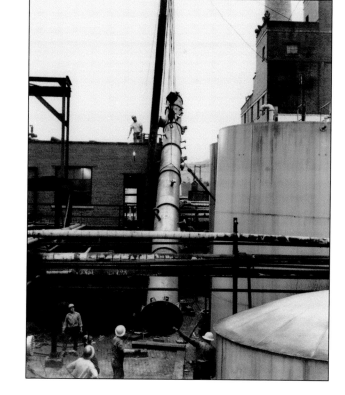

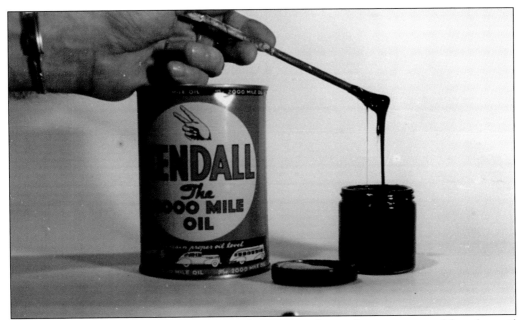

This promotional photograph demonstrates the amount of resin that was removed from base oil before it was blended into one quart of Kendall 2,000 Mile Oil. This photograph first appeared in a 1941 *Kendall Refining Bulletin*.

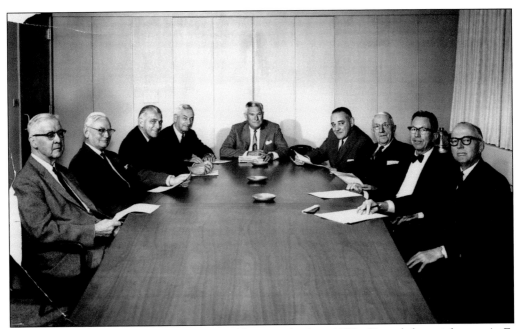

The Kendall Board of Directors is pictured here in the late 1950s. From left to right are A. E. Booth, Clarence Streeter, Harold Osborne, Sam Brill, J. Bert Fisher, Otto Koch Jr., Louis Koch, C. N. Pfohl, and Charles Perry.

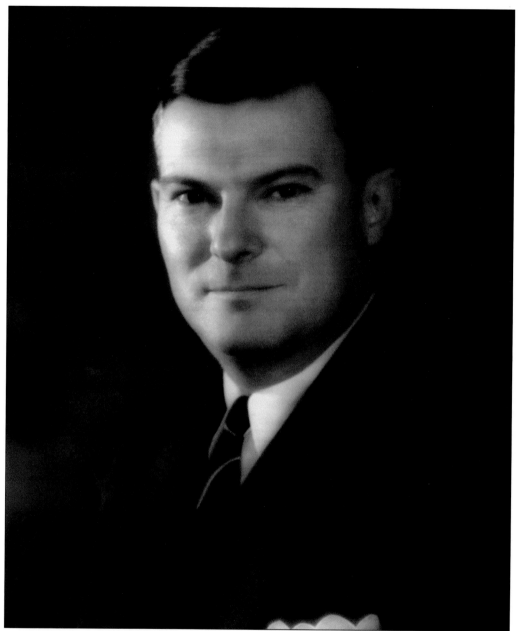
Handpicked by Otto Koch as his successor in 1943, J. Bertram Fisher (1899–1989) served as the president of Kendall Refining until 1966, when the company merged with Witco, and then served as a director and corporate vice president until his retirement in 1969. For 26 years, his name was synonymous with Kendall's; he was also a community leader, active in bringing the University of Pittsburgh to Bradford, gave timber rights for a century to Bradford Kiwanis to establish a tree farm in 1955, was a supporter of flood control in the early 1960s, and was involved with the Route 219 committee. Fisher, for whom a building at the University of Pittsburgh at Bradford is named, also received the Golden Deeds award in 1964. Fisher also held many important positions in the petroleum industry, serving as director of the Pennsylvania Crude Oil Association, among others.

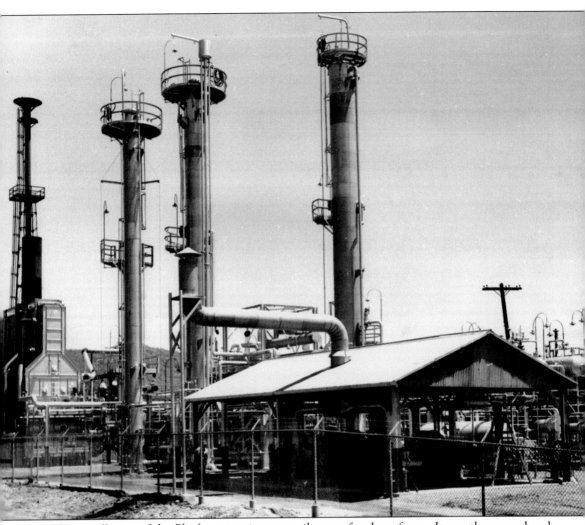

The installation of the Platformer unit was a milestone for the refinery. It was the second such unit to be placed into operation in the United States (the first was in Michigan) and the first such unit in Pennsylvania. Cost of the unit was estimated at $900,000 ($6.9 million in today's dollars). The name "Platformer" came from the use of platinum (valued at $70 an ounce in 1950) as an active catalyst in the refining process, but even that was recoverable, making the Platformer economical and efficient.

Construction of the new Platformer unit took months to accomplish. This next series of photographs illustrate the precise skill needed in assembling such a large unit—and most of it was done in the cold autumn months of 1950. Here workers prepare the site for the base. This photograph is looking southward, back toward Bradford, and is dated August 2, 1950.

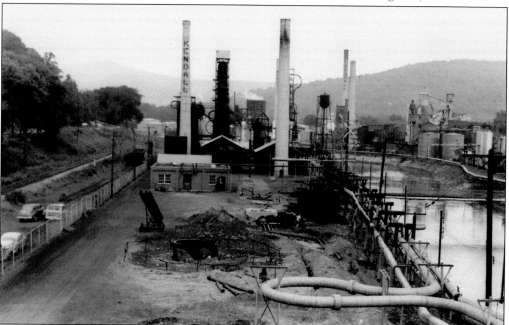

This photograph looks north toward North Kendall Avenue. The old water tower can be seen in the background. This photograph and the one above were taken on the same day but from different perspectives. Nearly all of the progressive construction pictures were photographed from atop that large storage tank in the background of the above photograph.

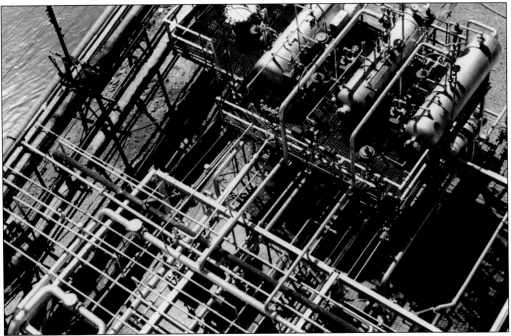

It has been said that all refineries have three things in common: lots of storage tanks, huge machinery and equipment that is always outdoors, and miles and miles of pipe. Here is a unique look at some of that pipe, from atop the Platformer unit, on September 13, 1951.

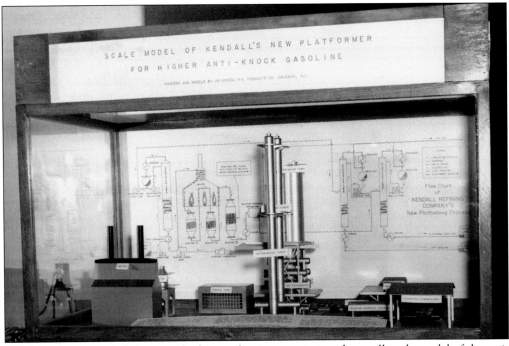

Kendall was so proud of the new Platformer that it commissioned a small-scale model of the unit illustrated with an accompanying flow chart that was displayed at the Emery Hotel and Emery Hardware Store during the month of January in 1951.

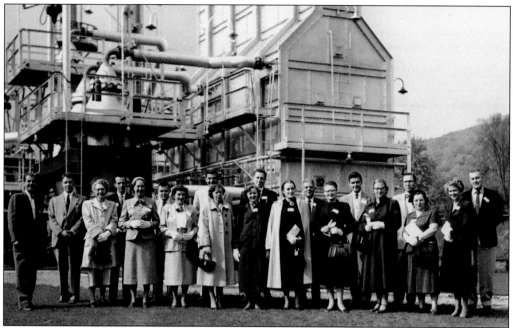

The general public is always curious about the day-to-day operation of an oil refinery. On October 15, 1952, an interested group of Bradford area schoolteachers stop for a group photograph in front of the recently (the year before) completed Platformer unit. Jack Eastman, the Kendall employee in charge of the tour, is at the far left.

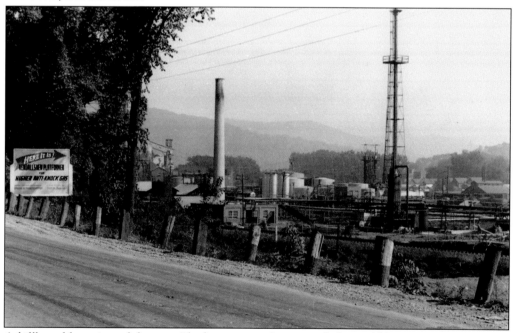

A billboard boasting of the new Platformer was also erected along old Route 219, at that time just a two-lane road that passed the refinery. Ironically, this 1951 photograph does not include a view of the Platformer unit (although it gives a good shot of the billboard), but does give an excellent look at the new flare tower.

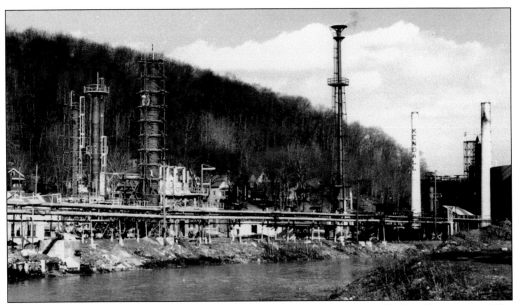

This photograph, taken on January 22, 1951, looks across the creek at the Platformer unit. The banks of the creek slope downward to the water; and it is easy to see how easily this creek could flood the refinery. Floods were a concern until flood control measures were instituted in the late 1950s. A flash flood on May 27, 1946, caused nearly $20,000 in damage as water reached its highest flood level in over 25 years.

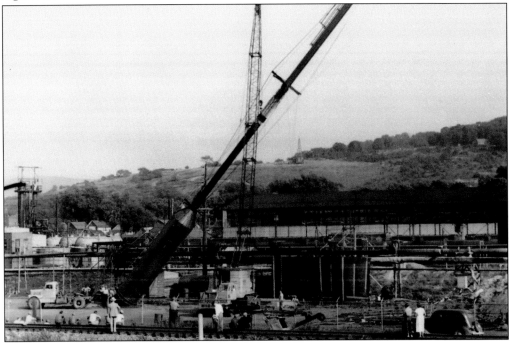

The raising of the field burner, or flare, was captured on film on August 25, 1950. As part of a $1 million improvement program at the refinery, this new field burner is hoisted upward with a large crane. The burner, or flare as it is commonly called, is 125 feet high and burns unusable gasses from the refining process. A second flare unit is set to be erected at the Foster Brook site in 2006.

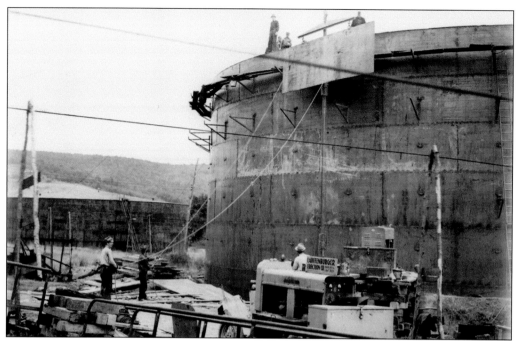

One of the major steel tank builders in the Bradford area for many years was the Lauffenburger Erection Company, founded in 1928 by Lewis Lauffenburger (1887–1981). It is believed that this oil storage tank was built in the Foster Brook area in the 1960s.

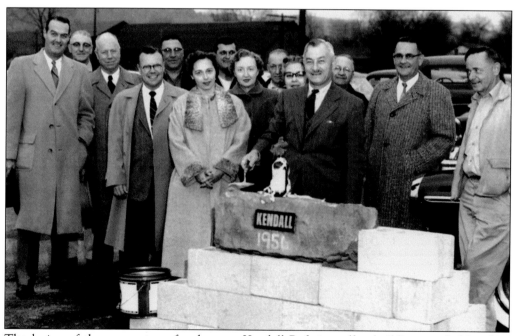

The laying of the cornerstone for the new Kendall Refining office building was held in late 1956. Actual construction of the building began in June 1957. Sam Brill is shown here, with the traditional "first trowel of cement" to get the project started. The object in front of Brill is a bottle of champagne with a ribbon around it.

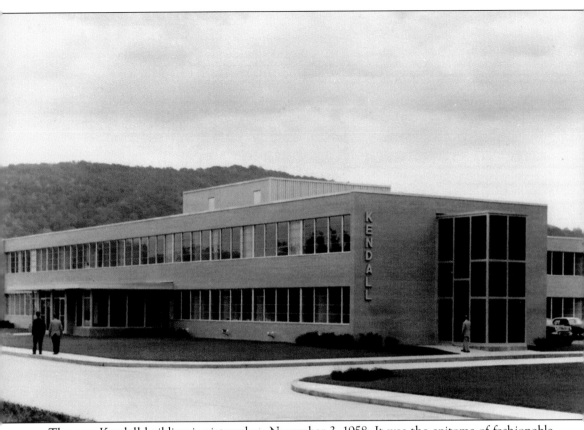

The new Kendall building is pictured on November 3, 1958. It was the epitome of fashionable style of the 1950s. "This handsome new office building, of pink brick and aluminum," was said to have room for 80 executives. Architect Preston Abbey envisioned a "streamlined, modern style," in a "T" shape to provide lots of windows. The north interior was painted a warm yellow with yellow and tan floors; the south side interior walls were cool green with floors of two shades of green tile. The exterior was constructed of pink brick veneer. Piped music in the corridors alternatively played for 15 minutes and was silent for 15 minutes during each working day. A notable feature was the lunchroom, with tables and chairs, an automatic food dispensing machine, and a small kitchenette.

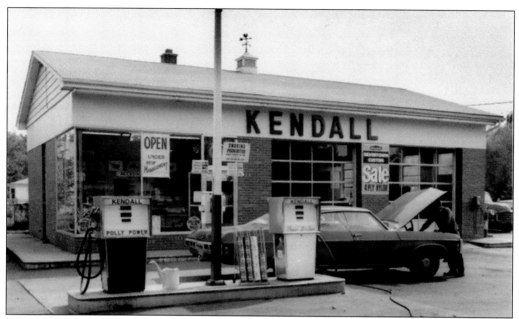

A Kendall Service Station is shown here in the 1960s. By 1947, there were 75 service stations owned by Kendall, all of them leased to private individuals. In 1941, Otto Koch wrote "the Kendall Selected Dealer sign . . . tells the passing motorist that here is a safe place to trade. Here you will find products of integrity and honest, reliable service." Note the "Polly Power" on the gas pump; this slogan was in use for over 30 years.

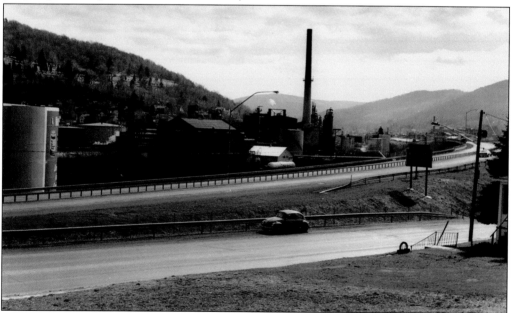

U.S. Route 219 passes right beside the refinery, a Bradford landmark. Most people driving along do not realize that the refinery produces all sorts of products, including gasoline, waxes, diesel fuel, fuel oil, naphtha, distillate solvents, special blends, shock fluids, camping fuel, asphalt cut back solvents, well-treating solvents, extract blends, dust suppressant, quench oils, rust preventatives, and of course, a wide range of finished lubricants.

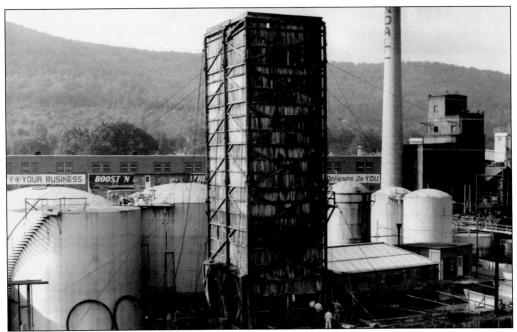

Demolition of the old wooden crude unit cooling tower is shown here in July 1958. The quickest way to demolish this obsolete piece of refinery equipment was to simply pull it down and let the creek carry the wood downstream. Notice the cables stretched across the Tuna Creek in the first of three photographs.

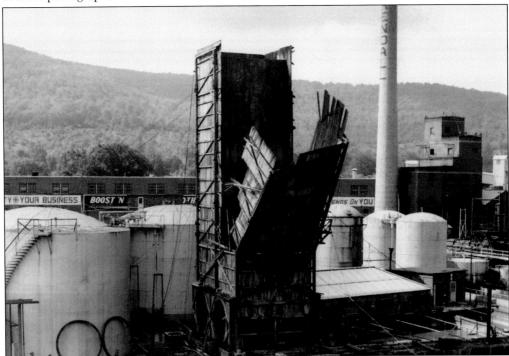

The tower begins its descent toward the creek. This cooling tower was located along the creek in the main part of the refinery on North Kendall Avenue.

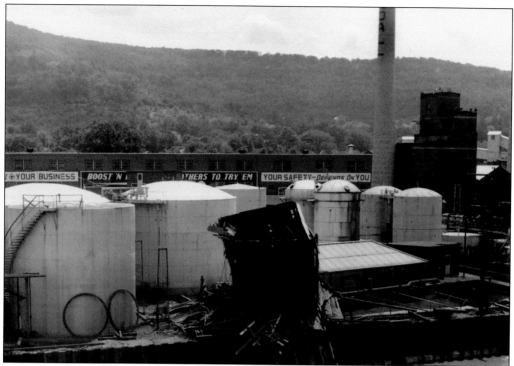
And away it goes, right over the bank. The rest of the cleanup only took a few days.

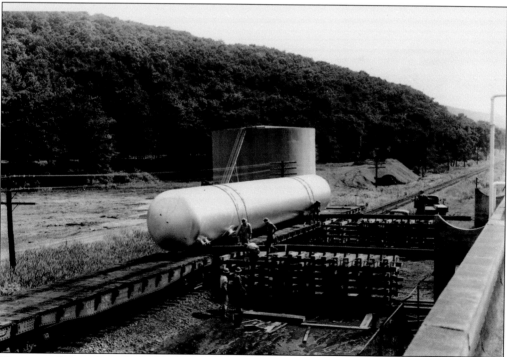
These men have a big job ahead, rolling a propane tank into position from a railroad flatcar. This tank is part of the ROSE unit and can be seen today from U.S. Route 219.

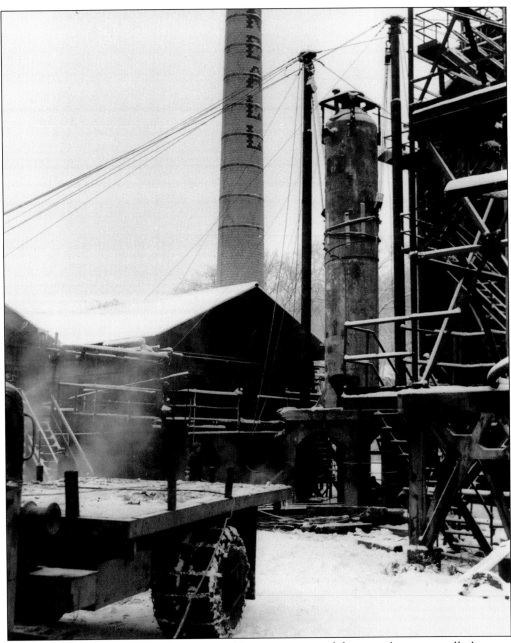

Installed in 1923, the Dubbs thermal cracking unit was used for years but eventually became obsolete as new technology evolved. Jim Zetts, a longtime Kendall employee, remembers that whenever work got slow at the refinery, a crew of men would go over to "the Dubbs" and start stripping it down. Eventually complete removal was accomplished, and today the Bio Treatment plant is located on this site.

Five

CHANGING TIMES

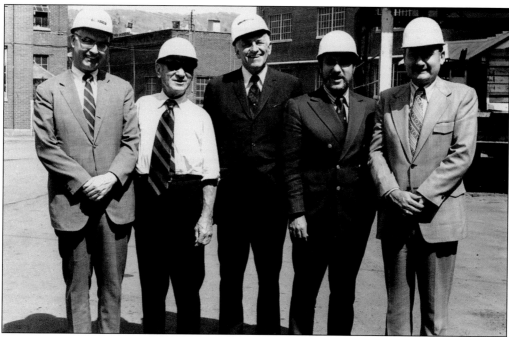

Witco Chemical Corporation officials are shown on a plant visit in 1972. In 1966, following a hostile takeover bid from Kewanee Oil Company, Kendall Refining proposed a merger with Pennzoil, another Pennsylvania oil refining company. The government blocked this merger, citing anti-trust laws. To prevent future takeover bids, a merger with Witco Chemical Corporation seemed the perfect answer. Witco was one of the world leaders in the manufacture of diversified chemicals and specialty petroleum products, and more importantly, the merger of Kendall Refining and Witco could not be considered a monopoly of crude oil production. This photograph shows two of the principal stockholders joining Kendall personnel for a tour of the facility on May 23, 1972. From left to right, Glen Gifford, Robert Wishnick, Hal Osborne, William Wishnick, and Ray Saunders pause for a photograph outside the barrel house. Robert Wishnick, second from left, was one of the principal founders of Witco.

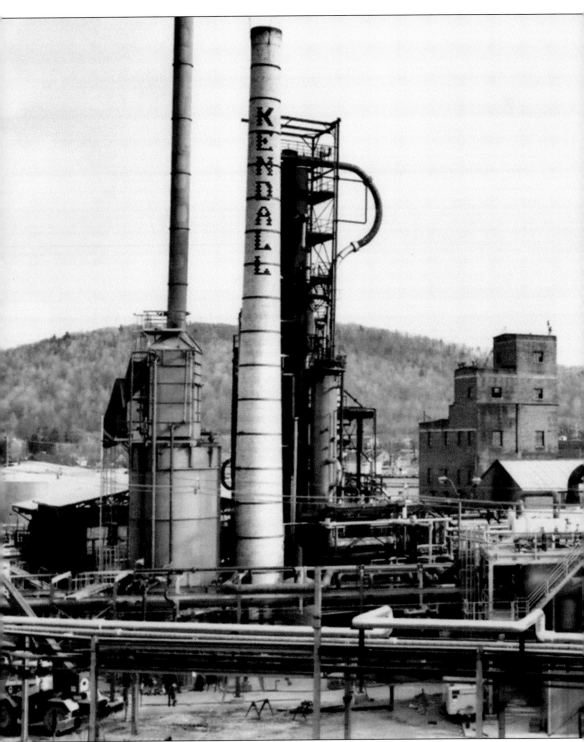

This photograph was taken on June 1, 1984, the summer before the new crude tower was put into place, and it captures a great panoramic view of the refinery at that time. The old Foster Wheeler unit, still standing in 1984, is located behind the Kendall smokestack; the older brick

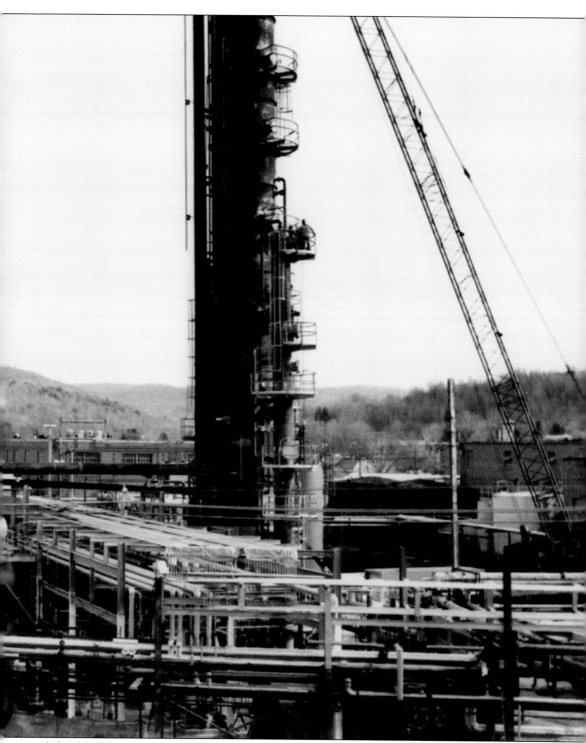
multilevel building in the background is the original boiler house; it still stands but has limited use in today's refinery.

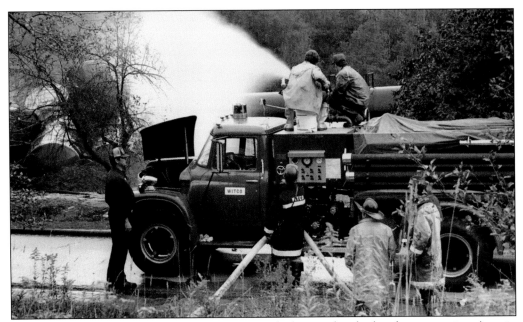

Highly trained refinery fire crews are experts in dealing with oil-related emergencies. A train derailment on September 17, 1980, created a tense situation as several railcars carrying petroleum derailed along High Street extension. Eleven cars exploded and caught fire as oil poured from the cars. The refinery crew was on the scene with foam used to control the oil fire, which could be seen for miles. Refinery employee Max Tyger is standing in front of the truck.

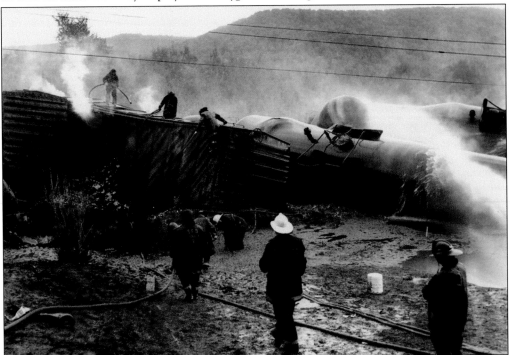

Here is another view of the derailed tank cars. Firefighters are still pouring on streams of water in an attempt to cool the cars. Each car could hold over 20,000 gallons of oil.

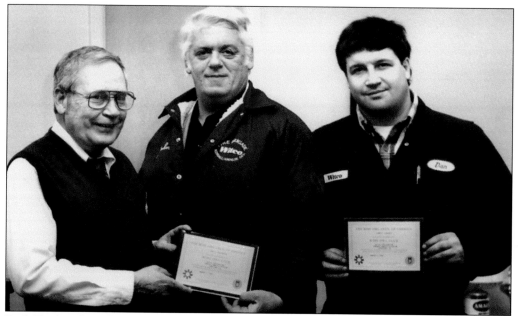

Paul Timbrook, refinery manager, awards Wise Owl certificates to employees John Corvett (center) and Dan Pascarella (right) in this photograph dating from the late 1980s. Sponsored by the National Society for the Prevention of Blindness, these awards recognize industrial employees who have saved their sight in one or both eyes by wearing safety glasses or other sight-saving devices. Awards usually included a membership certificate and a gold Wise Owl pin.

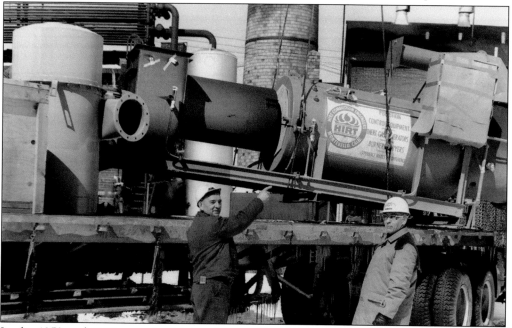

In the 1950 and 1960s, people driving through Bradford believed that they could smell oil in the air. This piece of machinery fixed all that. Installed on the Foster Brook reactor in March 1972, this pollution-control equipment, a fume burner to burn off noxious gases, became known simply as an "anti-smelling device."

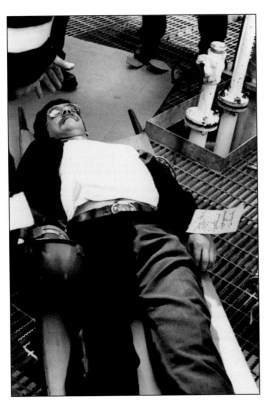

A disaster drill is held in June 1989. Constant practice is a safeguard against a real emergency. Volunteer employees are ready to serve as victims. Don Paul, one of the volunteers, has been tagged as having internal injuries and shock.

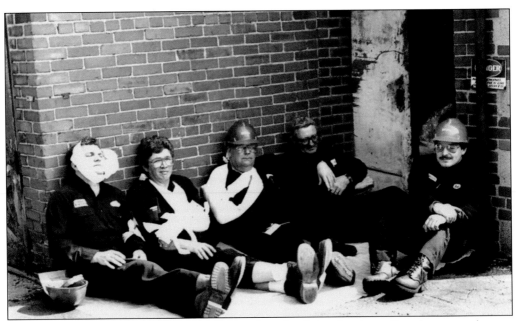

These employees may look as if it has been a long hard day, but in reality they are volunteer victims, taking part in a disaster drill that was held at the plant in June 1989. From left to right are Jerry Harvey with a bandaged face, Don Tracy with bandaged arms, Gene Eidson with a broken shoulder, an unidentified employee, and Bruce Kinney Jr., who seems to be recovering nicely.

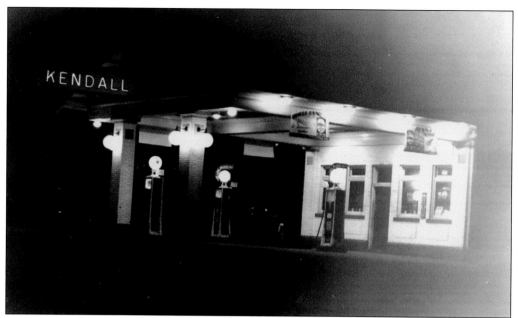

In 1971, the Kendall gasoline sales department converted five of the existing Kendall stations to Charger stations as a marketing plan to more effectively compete with private brand outlets selling only motor oil and gasoline, such as United Refining Company's Skat and Minute Man stations.

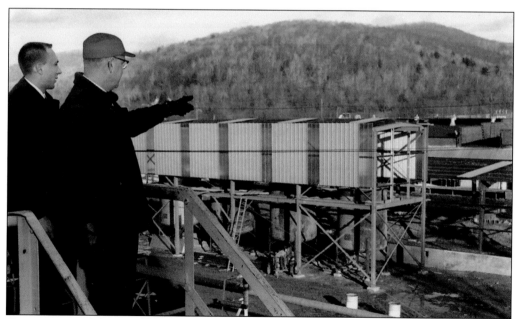

Construction of the new $250,000 blending and packaging plant at Foster Brook was underway in 1966. Here contractor Dick Kessell, in charge of construction, and Don McClure, head of the refinery instrument shop, look over the project. The four large blending vessels can be seen at the bottom of the unit. Completion of the project provided for the manufacturing of a growing line of Kendall products, including undercoating for motor vehicles.

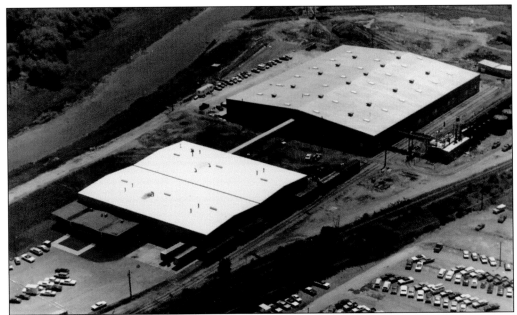

The new, $2.5 million, 82,000-square-foot Witco packaging plant (now ARG packaging) in 1969 was able to run 600 round, quart-size cans per hour. Fully automated, the plant received oil by pipeline from the refinery to the west and empty containers from R.C. Can (now Graham Packaging) via a suspended conveyor belt to the east. The conveyor can be seen running between the two buildings in the center of the photograph.

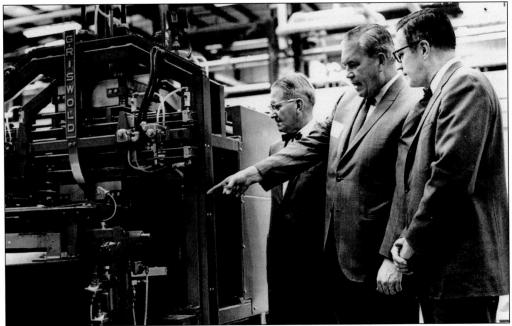

Witco Chemical Corporation and Bradford city officials tour the new packaging plant off Bolivar Drive on July 23, 1973. From left to right are Bradford mayor Oscar F. Benton, Witco president Max A. Minning, and Daniel Daly, one of the representatives of the Bradford Community Industrial Corporation. Minning is pointing out a feature of the machinery.

The March 18, 1979, fire in the barrel house is shown here. The Kendall fire brigade was quick to take action when a fire broke out at 7:15 a.m. on a quiet Sunday evening on the third-floor storage area of the barrel house on North Kendall Avenue. The Bradford City Fire Department was also called to assist, and the fire was under control within two hours.

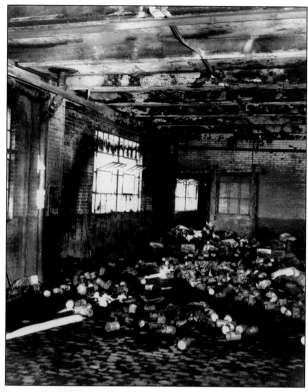

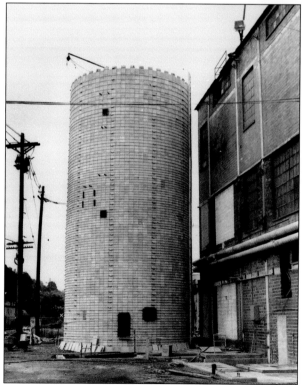

The building of a storage bunker for coal, a coal silo, outside the No. 2 power plant was underway on July 17, 1978. Insulation blocks, ready for installation, can be seen stacked at the base. Still in use, coal is one of the most cost-effective fuels.

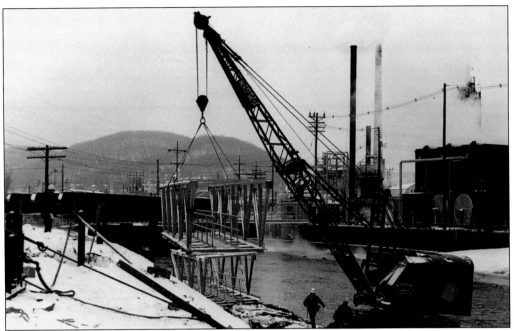

With the refinery stretched along both sides of the Tuna Creek, accessibility from one side to the other is always a concern. In December 1972, a fire loop bridge was put into place across the creek. This photograph was taken from the east bank of the creek; the extract cooling tower and extract heating stack can easily be seen in the background.

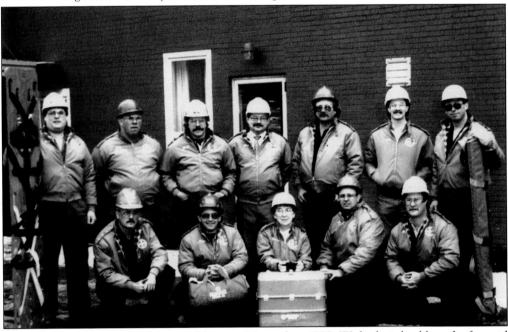

The safety response team is pictured here in November 1989. With their backboards, first aid kits, and training, this team is ready when needed. From left to right are (first row) Al Watson, Greg Fox, refinery nurse Rosamary Ditty, Joe Piganelli, and Marty Bechelli; (second row) Greg Dennis, Bill Woodring, Scott Hunt, Tom Friel, Pat Kelly, Bob Witton, and Andy Zias.

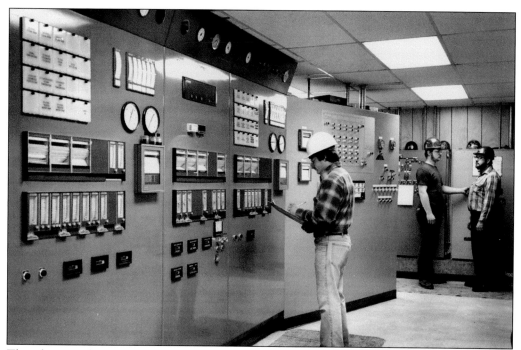

This photograph of the inside of the power plant control room was taken on December 5, 1979. Bruce Kinney checks the readouts while Randy Himes (left) and Jim Ludwig (right) discuss the day's work schedule.

Ray Masisak checks the viscosity of lubricating oil using a kinematic viscometer in 1960. Using a stopwatch, he is recording the "drop down" time of the flow of oil. The thicker the oil, the higher its viscosity and the greater its resistance to flow. A kinematic viscometer is considered very precise. The presence of several stopwatches indicates that he is testing several different oils at the same time.

87

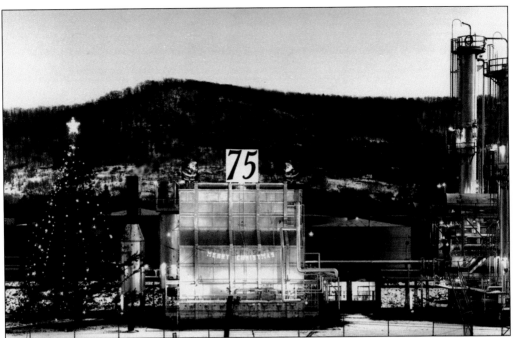

As 1956, the year of the 75th anniversary of the founding of Kendall, drew to a close, the refinery had one last gift to the community: a brightly lit Christmas tree and a heartfelt "Merry Christmas." The sign was erected on the Platformer furnace.

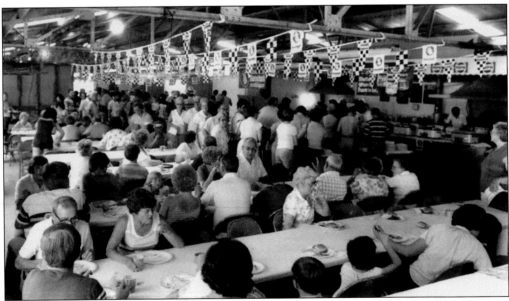

It was a gala time for all Kendall employees at the next celebration as well. The 100th anniversary company picnic was held on July 6, 1981, at the fairgrounds in Smethport, Pennsylvania. More than 1,350 employees and their families gathered for fun, food, and entertainment. The weeklong celebration saw dinners, dances, golf, tennis tournaments, meetings, and a special, commemorative 100th anniversary history book of Kendall. The entire celebration cost in excess of $104,000.

The Smethport Fairgrounds is shown here on July 6, 1981. It was the Monday after Independence Day, and many Kendall employees took advantage of a long summer weekend to attend the 100th anniversary company picnic. Although many wondered why a Bradford location was not chosen for the picnic, Witco officials explained that the fairgrounds were chosen in case of rain, as no Bradford club or organization could shelter such a large crowd if bad weather arose.

Bill Wishnick, chairman of the board and chief executive officer of the Witco Chemical Corporation, accepts a plaque from State Representative William Mackowski (right) while Raymond Saunders, vice president and general manager of Kendall Refining, looks on at left. The commemorative plaque represented a resolution passed by the Pennsylvania House of Representatives, honoring the 100th anniversary of Kendall Refining Company.

Although no one was injured, this home at 11 North Kendall Avenue was badly damaged the morning of February 5, 1980, when an unmanned oil tanker rolled backward down the street and crashed into the front porch. The driver had parked his tanker next to the Donut Depot at the top of the hill when the brake gear slipped. The tanker was moderately damaged, but the house suffered extensive architectural damage.

Strike was a word these women hoped to hear as members of a Kendall employee bowling team in the early 1950s. From left to right are (first row) unidentified, Betty Perry Nelson, Louise Lowe, Marie Milks, and unidentified; (second row) Ann Cloud McDevitt, Charlene Shannon, unknown, unknown, Sal Nick, and Emmabelle Walker. Another women's team of that era was the Gutter Dusters.

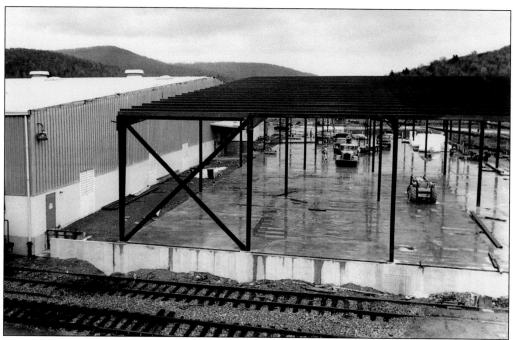

This photograph of the expansion of the packaging plant, taken on November 12, 1984, shows the steel framework in place.

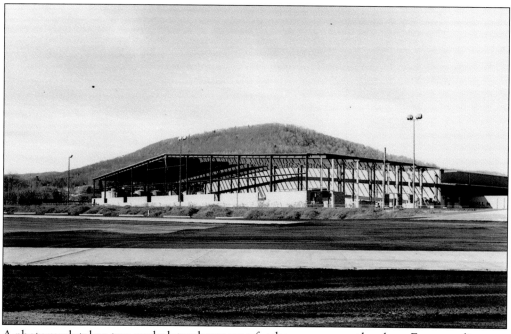

A photograph taken two weeks later shows even further progress on the plant. Even at a distance, one can see that it will be a very large building.

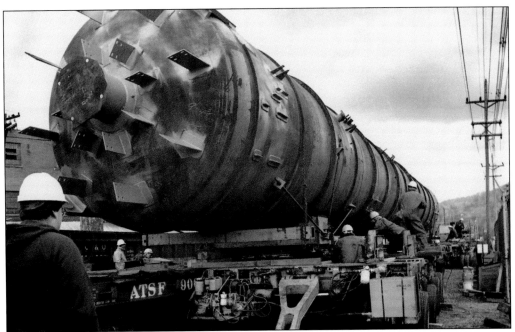

The new crude tower arrived on November 6, 1984. Shipped 1,400 miles by rail from Longview, Texas, this section of the tower, or fractionation unit, is shown being rolled off the railcar onto a tractor trailer and secured for its transport to the Bradford refinery. This 130-foot tower is the largest section of the new tower, which was put into operation in May 1985, replacing the 56-year-old Foster Wheeler unit.

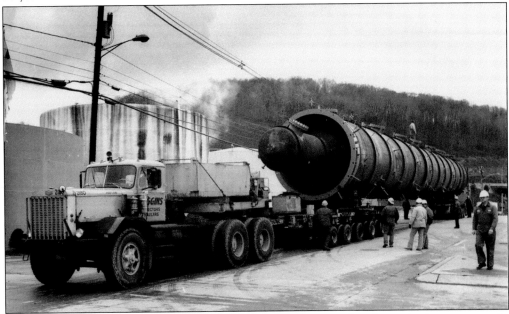

The tower arrived by truck at North Kendall Avenue. Because of its huge size it was not easily maneuvered. The truck hauling this giant tube turned into the driveway of the administration office, straightened out, and then began its backward journey through the refinery gates. Careful and steady it goes.

Once inside, a huge crane secured the top end and began to lift it off the transport truck. The tower measured 130 feet in height, and the crane was much taller than that. It raised the tower without mishap or injury. The old Foster Wheeler unit can be seen in the background behind the crane. It was demolished within the next few months.

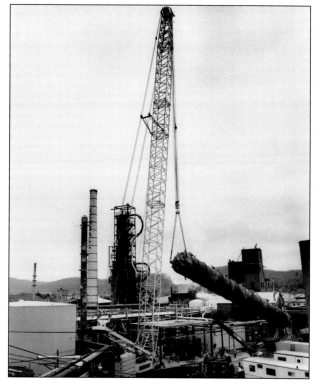

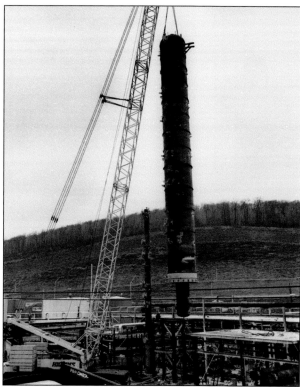

The tower is lowered into place. The preliminary groundwork for installing this modern fractionation tower took months. Several more months were needed before the equipment was in its proper place and ready to go.

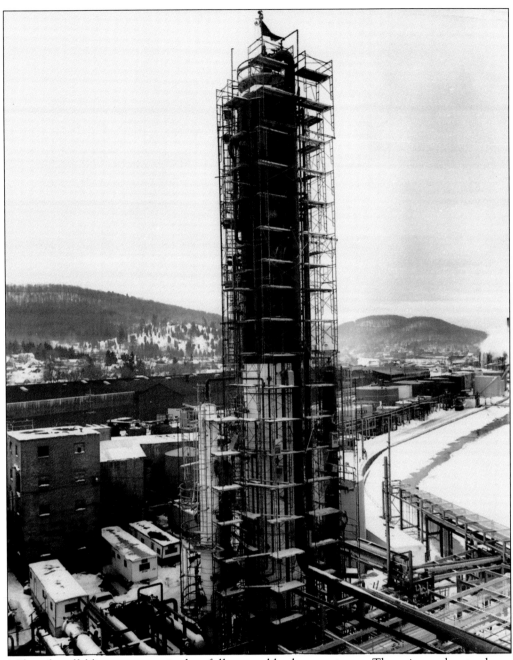
Miles of scaffolding were required to fully assemble the new tower. There is no elevator here; each level must be reached the old-fashioned way, legwork.

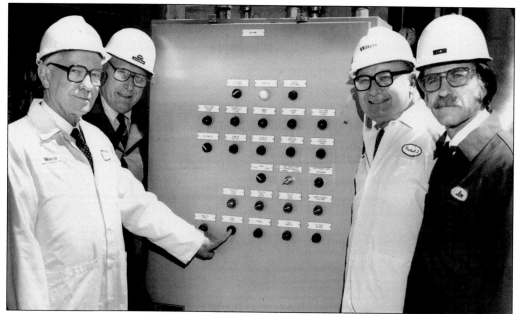

It takes more than just one push of a finger to start ignition of a crude furnace, but these Witco officials seem to make it just that simple. W. J. Ashe, president of Witco, is shown initiating startup on May 3, 1985; Henry Pruch, general manager of Witco Operations in Bradford is behind Ashe; Ray Saunders, Petroleum Group vice president, and Jim Warwick, general manager of manufacturing, are at right.

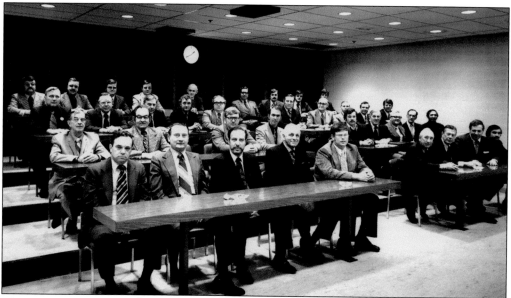

The Kendall division of branded lubricant sales staff gathers at a sales conference in this January 30, 1974, photograph. Among those present are Henry Levkoff, corporate vice president of the petroleum division; Ray Saunders, corporate vice president and general manager of Kendall-Amalie Division; Bill Wishnick, chairman, president, and chief executive of Witco Chemical; and Hal Osborne, corporate vice president, special products for Kendall-Amalie. All four men are seated in the front left row. The fifth man, seated next to Osborne, is unidentified.

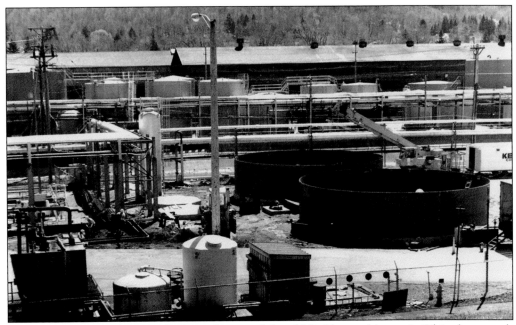
The Bio Treatment plant was built on the site of the old Dubbs cracking unit. This photograph shows beginning construction of the two wastewater tanks where all wastewater from the refinery is treated.

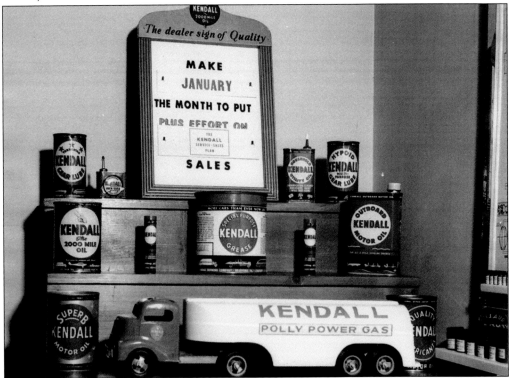
This Kendall Oil display is dated December 28, 1954. All of these containers are highly prized by collectors of oil memorabilia.

Six
THE REFINERY OF TODAY

One of the first sights a visitor sees when arriving at the American Refining Group Inc. headquarters at 77 North Kendall Avenue is this sign, located right outside the front door. The windmill design is the official logo of American Refining Group Inc.; and, just as windmills harness the wind for energy, American Refining Group Inc. harnesses oil for the same purpose, continuously improving the refinery facilities and operations by investing in new equipment and technology. Many of the refinery's 270 employees have worked here for years, and some are second- and third-generation employees.

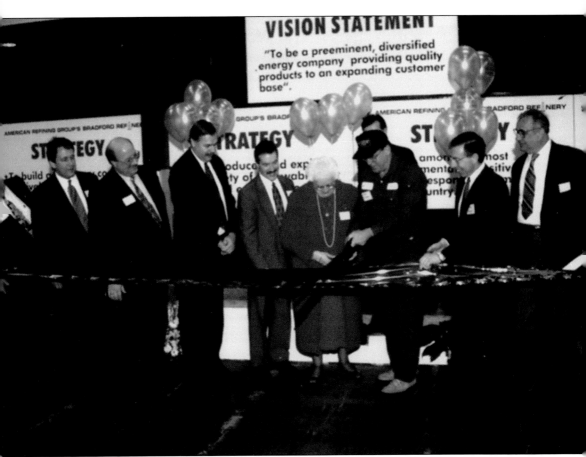

March 7, 1997, was a day of celebration. Nearly 400 employees and officials happily greet one another at a huge party in the empty packaging plant to celebrate new ownership and a promised future for the Bradford refinery. The Kendall and Amalie division of the refinery, formerly owned by Witco Chemical Corporation, was sold in early November 1996 to Sun Oil, leaving the refinery workers wondering just what lay ahead. Finally, after months of negotiations and some financial incentives, the former Kendall Refinery was purchased for $1 (plus another $17 million for inventories and working capital) by American Refining Group Inc. and saved, in effect, from extinction. Harry Halloran, one of the new owners; Bradford mayor Connie Cavallero; Steve Kohler, director of the Governor's Action Team; Harvey Golubock, new American Refining Group president; Ray McMahon, director of the Office of Economic and Community Development; and others are shown here, cutting the ribbon at a symbolic opening of the Bradford refinery under American Refining Group management.

New president and chief operating officer Harvey L. Golubock (left) and new owner Harry R. Halloran Jr. (right) are pictured here. Golubock, a former Witco group vice president, was named to his new position just days before the official opening of the refinery under American Refining Group ownership. Halloran, who holds degrees in both civil engineering and theology, attended the function dressed in the blue uniform of an ordinary refinery worker, a nice touch that endeared him to the local newspaper and new employees.

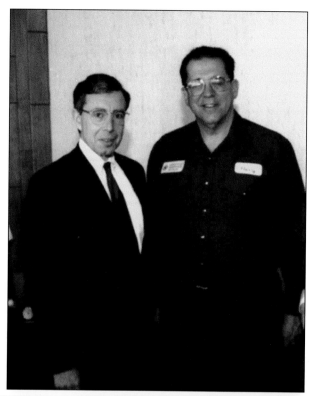

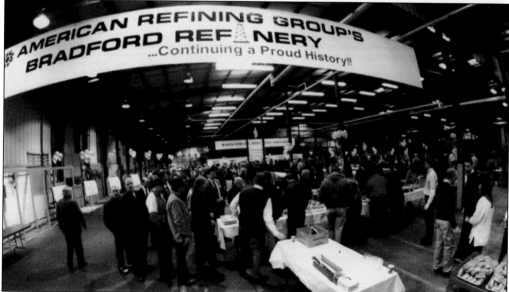

The new owner of American Refining Group, Harry R. Halloran Jr., stressed that the company would operate under the following principles: providing quality products to customers, being environmentally sensitive, creating inspired and enthusiastic employees, exploring renewable and conventional energy resources, and having a dynamic and innovative company. The party, a five-hour affair, introduced those principles on large signboards placed around the empty packaging plant. Halloran pledged to start it up again. In the fall of 1997, this pledge was realized.

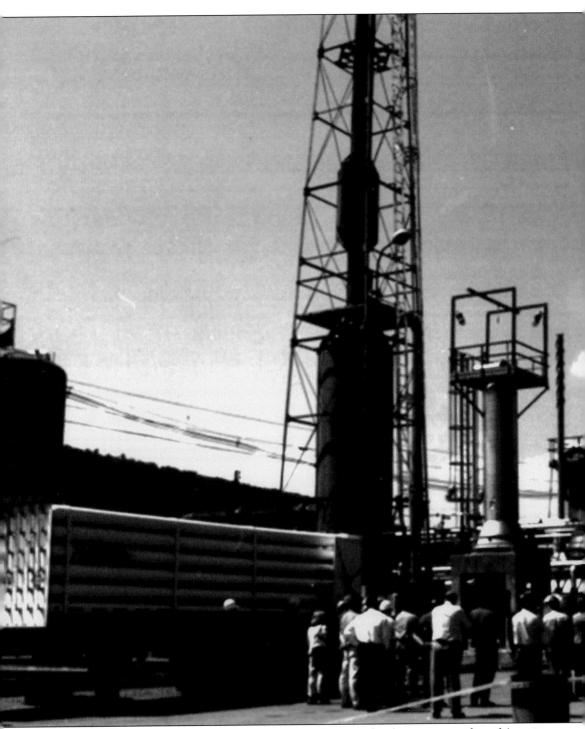

One of the first major improvements made to the refinery under the new ownership of American Refining Group was the installation of an Isomerization unit in July 2003. Construction of the new unit took almost two years. Isomerization is a process that increases the octane of gasoline

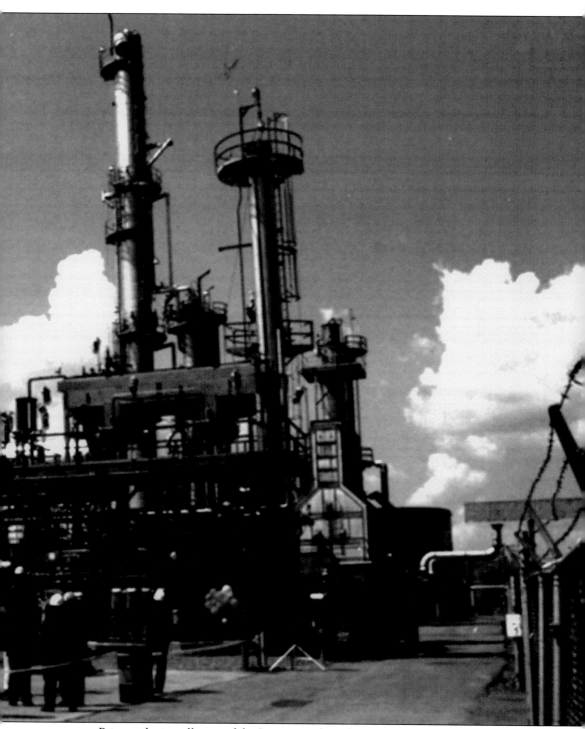

components. Prior to the installation of the Isom unit, the refinery was capable of producing only low-grade or 87 octane gasoline. With the new unit, high octane gasoline is also produced.

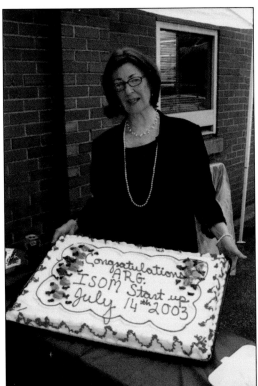

A smiling Susan Sinclair, executive assistant to Harvey L. Golubock, displays a cake celebrating the start-up of the new Isomerization unit on July 14, 2003. Sinclair has been an employee of American Refining Group since 1997.

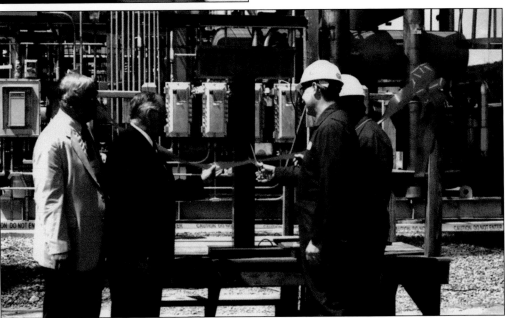

On the drawing board for years, even dating back to when Witco owned the refinery, the new Isomerization unit started up on July 10, with the official opening scheduled on July 14, 2003. Funds to pay for this latest addition came from state grants, city loans, township loans, and from the cash flow of American Refining Group itself. The new unit is visible from Route 219, between North Kendall Avenue and Mill Street.

The ceremony over, two workers go back to work at the refinery. From the highway, it often seems that the refinery is a jumble of pipes and huge machinery, but the employees know the location and purpose of each piece of equipment in a seemingly enormous maze.

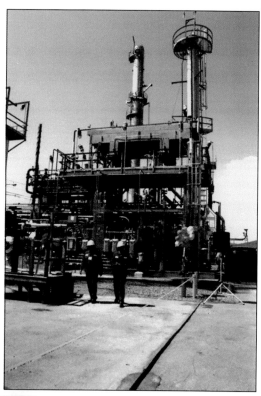

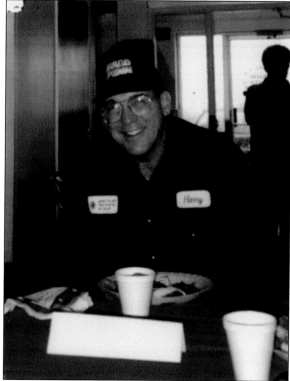

Harry Halloran enjoys a piece of cake and refreshments following the dedication of the new Isom Unit on July 14, 2003. Halloran, owner of American Refining Group Inc., has put his business ideals of fair wages, ethical management, and environmental responsibility to practice here at the Bradford refinery.

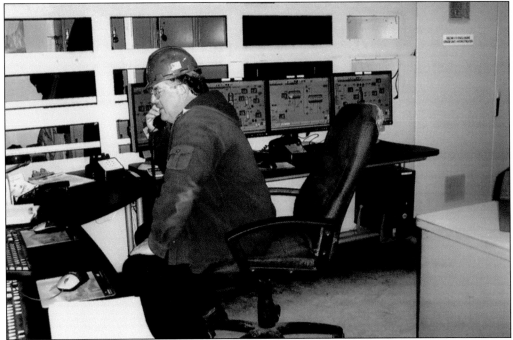

Inside the control room of the crude unit is seen here. Mike Maholic, operator, has modern computers to help monitor the atmospheric distillation processes inside the unit that fractionates Pennsylvania Grade crude oil into eight liquid streams and one fuel gas stream. These products are naphtha, middle distillates, wax distillate, heavy wax distillate, and cylinder stock. The new computerized control system was installed in 2006.

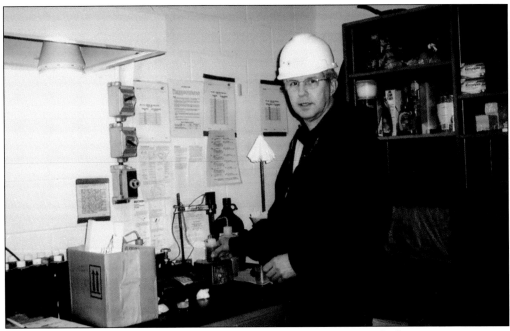

Dave Schierer, quality control laboratory employee, is testing the pH of oil.

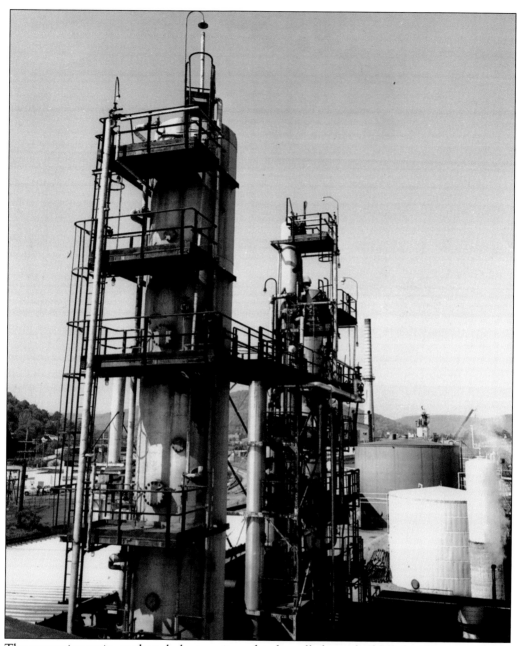

The extraction unit, or phenol plant, as it used to be called, was built in the 1930s, and at the time was the first and only one in Pennsylvania. Back then, it used phenol, a dangerous gas that causes severe burns and can be fatal if inhaled. In 1981, the refinery licensed technology from Exxon to upgrade the unit to a different solvent extraction process. Basically, it "extracts" aromatics from the feed stock. This process improves the quality of the lube stock. This is the oldest unit in the refinery and shares a control room with the ROSE unit.

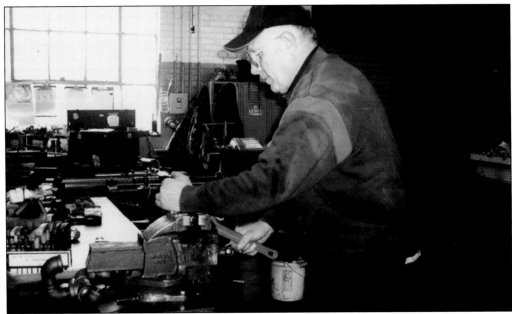

Inside the machine shop, Ken Slotta is removing bearings from a pump jack. The refinery has several specialty shops, such as welding, machinery, automotive, maintenance, pipe shop, and so forth, that are responsible for the smooth operation of the refinery on a day-to-day basis. The refinery runs 24 hours a day, 365 days a year, never shutting down, and these men are an important part of its success.

Randy Himes concentrates as he begins tearing a pump apart.

With his drawings spread out on a work table, Brian Boschert looks up from drawing a piping diagram.

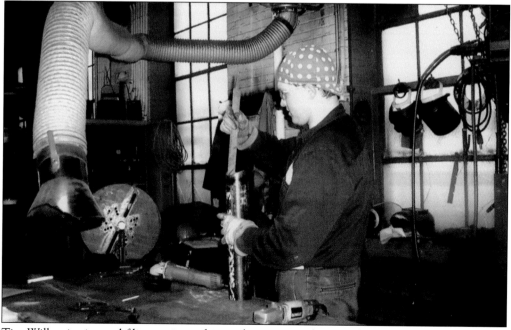
Tim Wilber is pictured filing a pipe at his work station in the pipe shop.

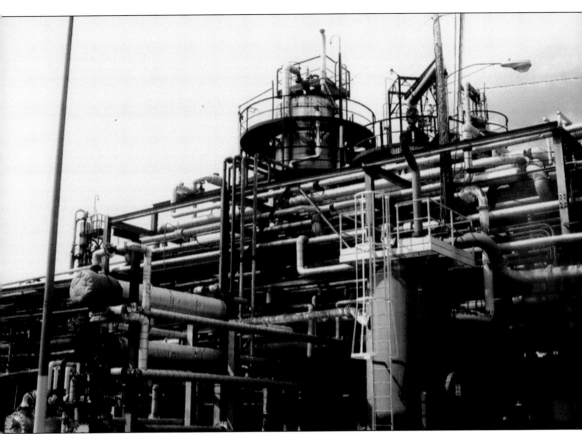
The ROSE unit is one of the highest-pressure units in the refinery. It was constructed in 1986 to phase out the deresining portion of the 1936 D and D plant. Products include waxy finished oil, heavy resins, and light intermediate resins. Heavy resins are a key ingredient in producing PennzSuppress, a dust suppression material blended at the Foster Brook plant.

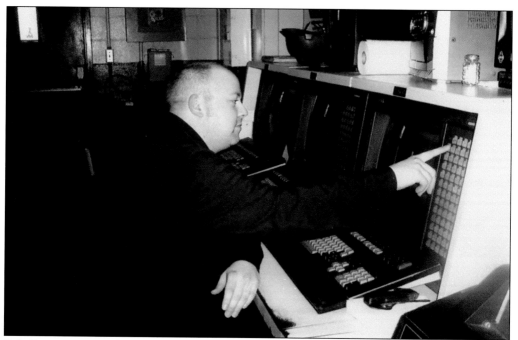

Rob Evers, operator, keeps a close eye on the control screen of the ROSE unit. The acronym ROSE stands for Residual Oil Supercritical Extraction.

The refinery itself has an office building inside the main complex. Built before 1925, this two-story brick building houses refinery management and engineering.

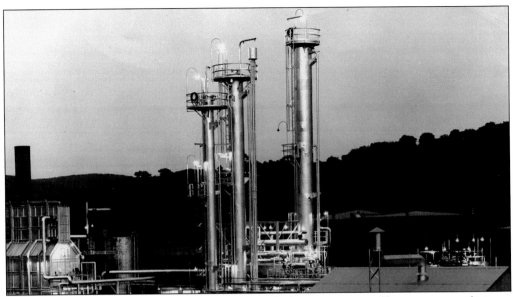

Erected in 1951, the Platformer is still in use today. Platforming, so named because it uses platinum as an active agent in the catalyst, was recognized as the latest and most modern advancement in petroleum processing equipment in the 1950s. At the time of its installation at the Bradford refinery, this unit was the second such unit in the world to be placed into operation. This unit processes the naphtha that is distilled from the crude oil at the crude unit. Several renovations have been completed over the years: in 1953, an oxygen stripper was added to improve stream time; a third recycle compressor was installed in 1956; and a naphtha fractionator was added in 1991. This striking night photograph was taken in 1958.

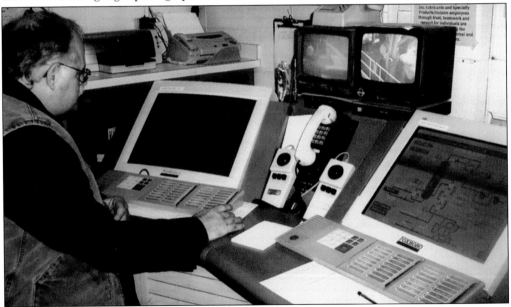

The Platformer control panel is closely monitored by Carl Edwards, an American Refining Group employee. Several of the units are now being monitored by computers, another step forward in modern crude oil refining. The Platformer, built in 1951, still uses platinum and other elements as catalysts.

Matt VanScoter bends a conduit pipe beneath the Platformer unit.

An important job in the quality control laboratory is data entry into the computer. Here Bob Keith takes a moment to make sure all the entries are correct.

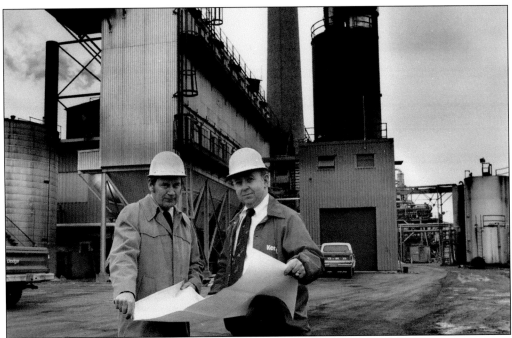

At the boiler house, on the bag house side, are Paul Timbrook (left) and an unidentified man in this Witco-years photograph. The bag house is so named because it holds special bags designed to filter out and collect fines from coal ash from the boiler house.

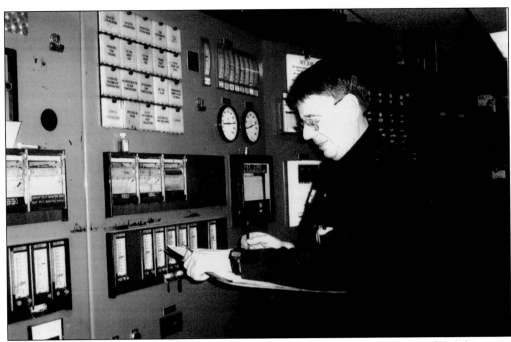

Carl Clark, an operator at the boiler house, checks the controls. At one time, all of the major operating units were operated by control panels such as this one; eventually all will be replaced by computer screens, but it will still take a qualified employee to supervise.

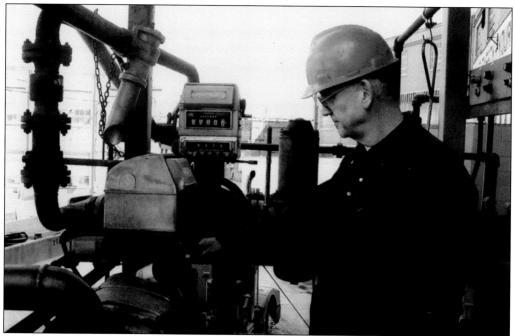
Steve Hepfer is at the controls, loading a truck outside the barrel house.

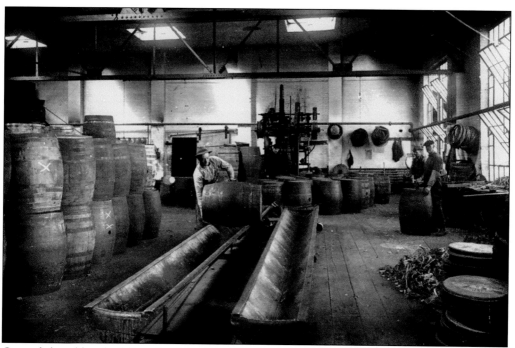
One of the oldest buildings in the refinery is the barrel house, erected in 1918. This man is filling a wooden barrel with oil in this c. 1925 photograph. A barrel holds 42 gallons of oil, a size standardized in 1866. Today's refineries no longer use wooden barrels to store oil, but traditionally oil is still measured, sold, and priced by the barrel.

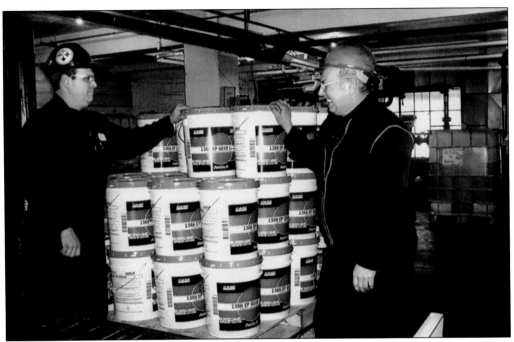

This view inside the barrel house was taken in 2006. Tom Welch Jr. (left) and Randy Holsinger seem to be enjoying their work, as they stack up five-gallon buckets of gear lube for distribution.

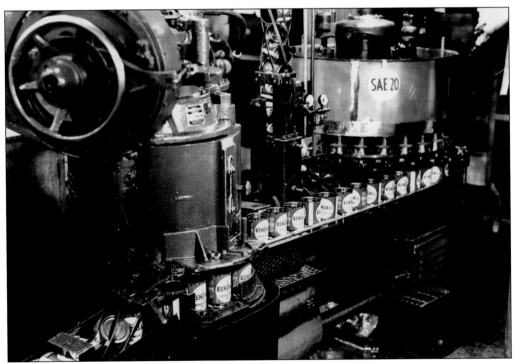

Back in the 1940s, the barrel house filled and sealed cans for motor oil, as seen in this photograph from that time period. When initiated, back in the 1930s, factory-sealed oilcans were a revolutionary idea. Today cans and bottles are filled in the new packaging plant.

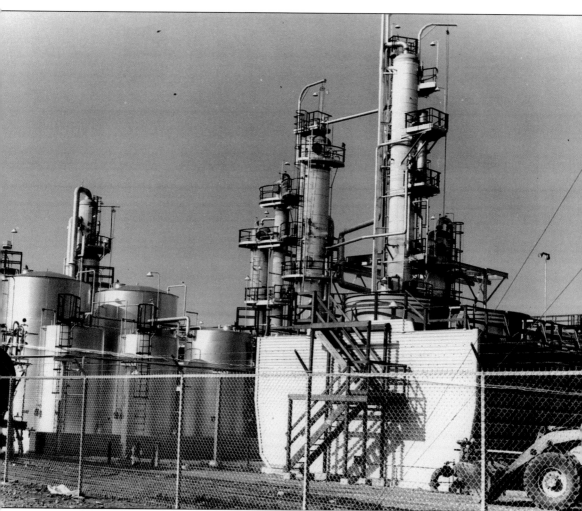

The MEK dewaxing unit is pictured here in 1970. The new facility for dewaxing lubricating oils and making refined waxes was operational in December 1970 and cost $6.5 million. Methyl ethyl ketone and toluene are the dewaxing solvents in which lube stocks are chilled, so that waxes detrimental to low-temperature operation of engines can be removed. Located on the south side of Mill Street, the new unit was built by Foster Wheeler of New Jersey. Filters and various other improvements have been added since this plant was completed 30 years ago; these modifications also allowed for the processing of deresined cylinder stock and allowed for the decommissioning of the dewaxing section of the old D and D unit.

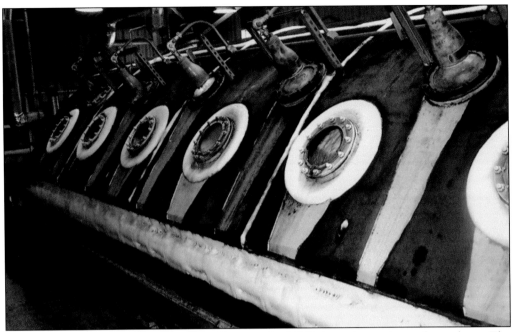

Observation ports for four rotary drum filters at the MEK dewaxing unit are shown here. The filters physically remove wax crystals from the solvent-wax-oil slurry to produce lubricating oil that can flow at less than zero degrees Fahrenheit. Additional filtering capacity was added during the 1980s.

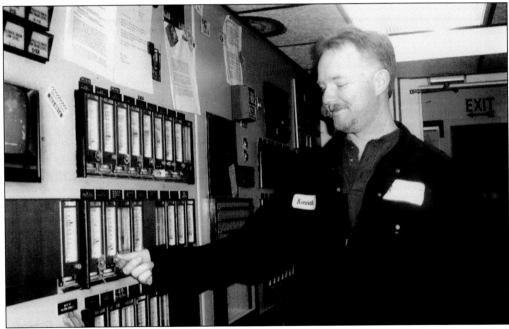

Ken Seagren, a shift breaker, starts his shift by checking the MEK unit control board. A shift breaker is used to fill in at a unit when needed and quickly learns to adapt to various work sites.

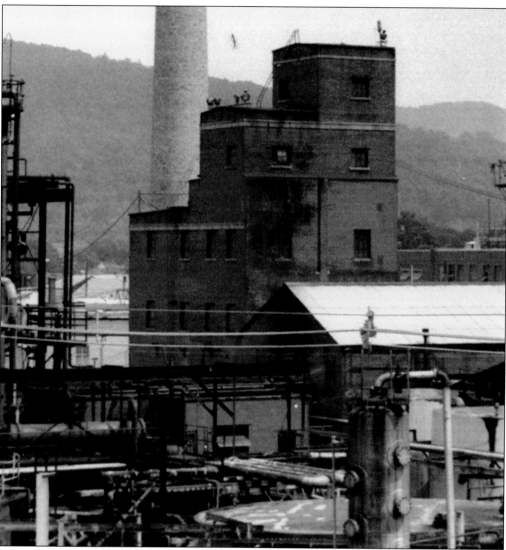

Erected in 1912 as one of the modern improvements made by Otto Koch, this old, brick, multilevel boiler house has served many purposes, but is no longer used. Its large size and close proximity to other large refinery equipment worth millions makes simple razing a difficult task.

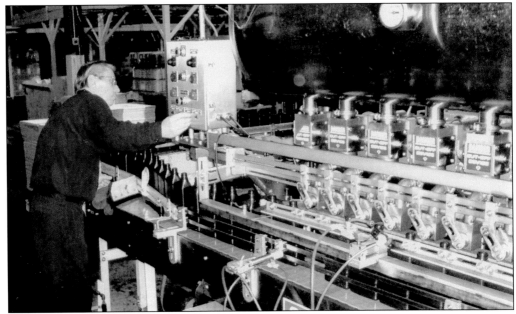

Inside the packaging plant, John Bisker is adjusting the controls. He is monitoring the machine that is filling quart containers with oil that will be sold under the refinery's own brand, Brad Penn. The containers, which first pass through the pressure-sensitive labeling machines, will eventually be carried on special conveyor belts to other stations inside the plant.

Here the plastic bottles receive their labels via a high-speed label machine that can label and move 150 bottles per hour. American Refining Group sells and packages products for a variety of customers, as well as marketing their own products. Halloran's earlier promise to restart the packaging operation has been fulfilled.

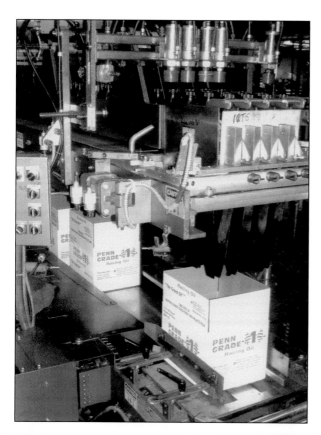

Penn Grade Racing Oil boxes come riding down the conveyor belt at the packaging plant, which has many labor-saving machines that fill, label, move, and package containers.

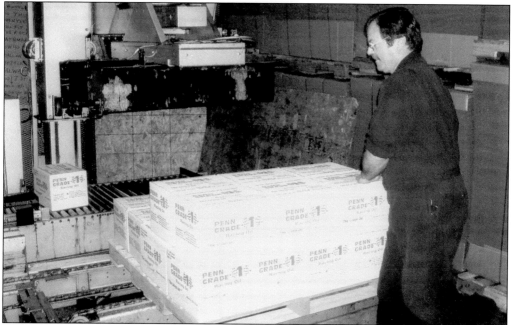

Ken Eddy oversees the palletizing of the boxes inside the packaging plant. Finished products are palletized and stretch wrapped on new heavy-duty pallets.

Jim Swackhammer, from Commonwealth Trucking, stops unloading crude oil for a moment to talk with environmental health and safety leader Dawn Kozminski. Kozminski is just one of 44 women who work at the refinery; most work in research or office environments.

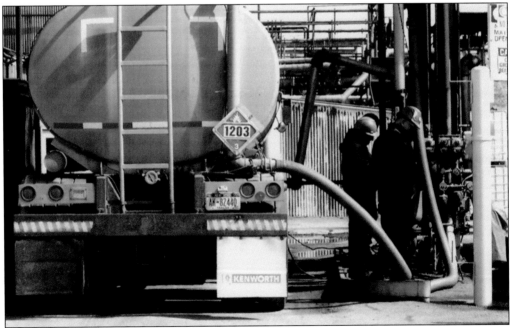
Loading a tanker at the Foster Brook bulk plant, Harry Pearce and Ken Toothman, both American Refining Group employees, help an out-of-state truck fill up.

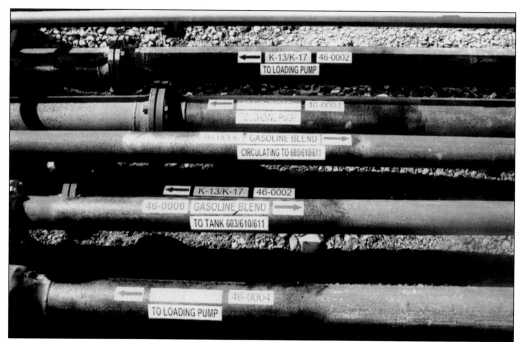

Pipe markers clearly identify from where and to where the oil or gasoline flows. These pipe markers can be seen at the Foster Brook tanks.

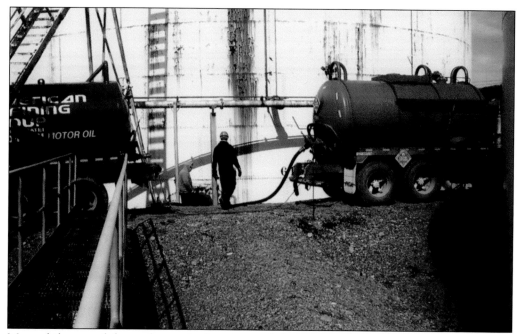

Meanwhile one of the tanks needs cleaning, and the maintenance department is on the job. David Goodling walks over to the vacuum truck as Bob Moonan gives encouragement to the men inside the tank. Employees, who must crawl through a small opening in the bottom of the tank, are using a vacuum hose attached to the American Refining Group truck to help clean the tank.

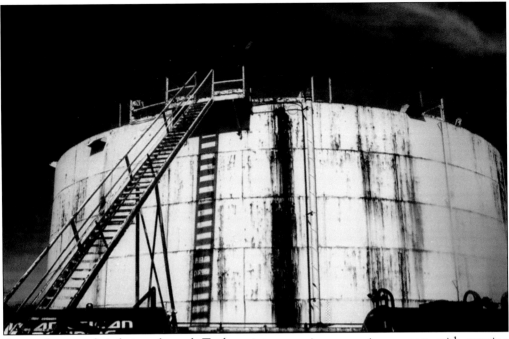

A very large tank is being cleaned. Tank maintenance is an ongoing process, with rotating schedules for painting, cleaning, and replacing. This tank, located at Foster Brook, is just one of the 395 tanks on the American Refining Group refinery property.

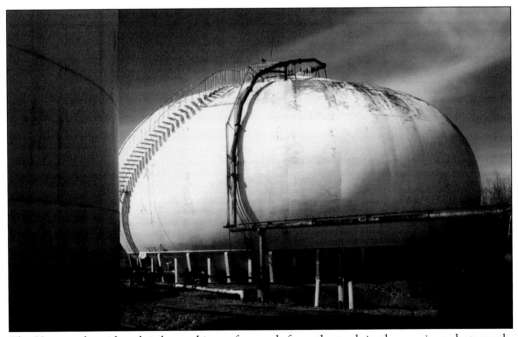

The Hortonspheroid tank is located just a few yards from the tank in the previous photograph. Now 55 years old, it still maintains its structural integrity.

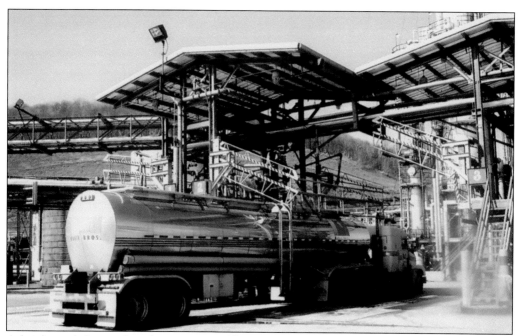

A bright and shiny oil tanker arrives to fill up inside the refinery. Usually several different oil company trucks can be spotted lined up on the driveway in front of the main American Refining Group office building. They are simply waiting their turn to get into the refinery.

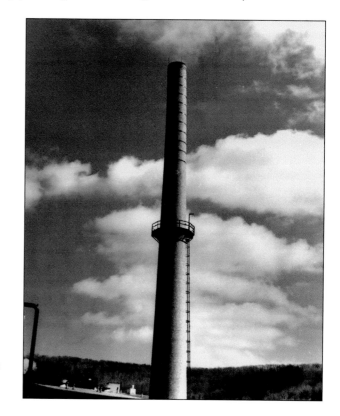

This stack, located close to Mill Street, is the last remaining brick stack and currently has the initials ARG painted down the side. Interestingly, this particular stack is a remnant of the Emery Manufacturing Company of the 1920s; it has seen more changes to the refinery and has lasted longer than any other structure.

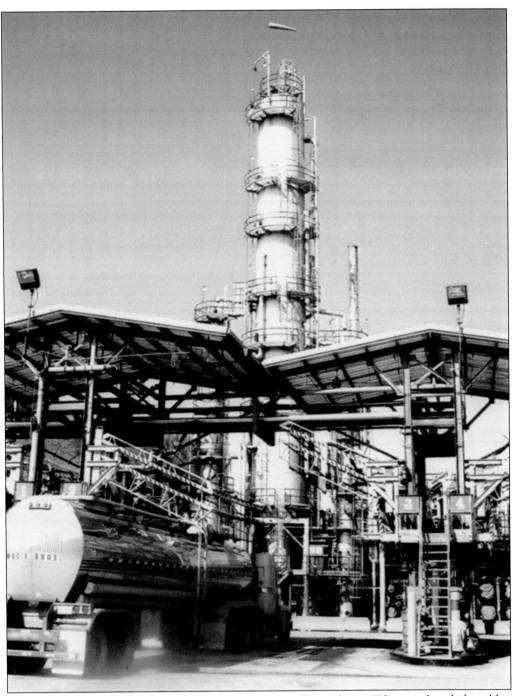

Inside the refinery is a good view of the crude unit. Erected in 1985, it replaced the older, obsolete Foster Wheeler unit, which dated from 1929. The modern crude unit is much more energy efficient than its predecessor, and has an increased barrel-per-day capacity, from 6,500 barrels to 10,000 barrels. This distillation process consists of the main fractionating tower, six side stream strippers, three pump arounds, and an overhead condenser.

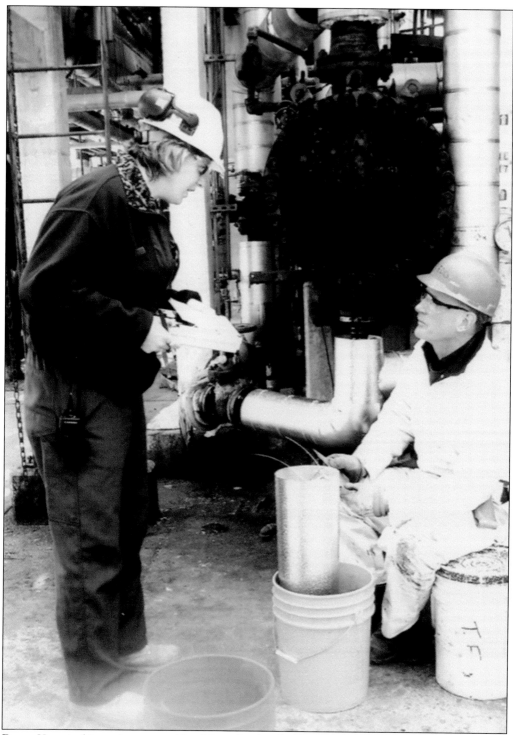
Dawn Kozminski, environmental health and safety leader, checks with Tom Federspiel, who is insulating a pipeline. Both are wearing hard hats and safety glasses, required of all employees inside the refinery.

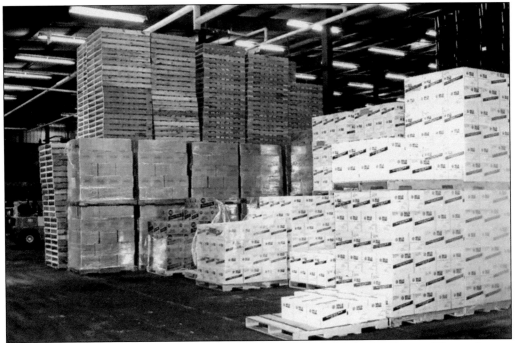

At the end of the day, there are piles of cartons ready to be shipped to customers. The packaging plant not only fills, seals, and packs boxes, it also palletizes shipments, and stretch wraps orders. Depending on the size and type of order, anywhere from 5,000 to 10,000 cartons are processed each shift.

The American Refining Group company flag is shown flying near the refinery entrance.

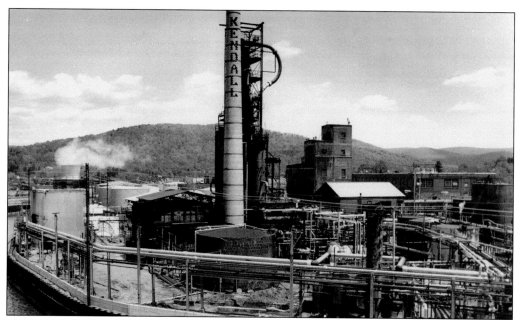

Take a look back at the refinery of 20 years ago, in 1984. There have been many changes since that time: new ownership, new equipment, new technology, and new views on how to run a refinery. For a time, in late 1996, it seemed as though the refinery might close, but a white knight, called American Refining Group, came to the rescue. The Kendall name is gone, but the memories of the past 125 years remain, and new memories, under American Refining Group, are ahead.

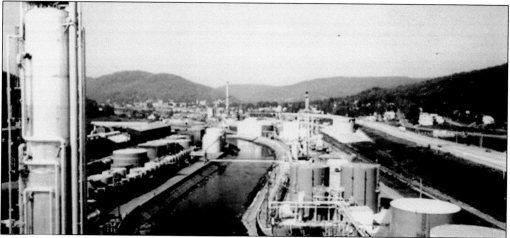

Today, in 2006, in addition to gasoline and fuel oil, the refinery produces a complete line of solvent naphthas and distillate solvents under the Kensol brand, Kendex brand lubricant base oils, waxes, and Penn Grade resins, Pennzsuppress brand dust control agent, and a variety of other petroleum specialties. American Refining Group also produces a complete line of Brad Penn lubricants for consumer, commercial, and industrial applications and is designated as the master distributor for Gulf branded lubricants in an 11-state region in the Northeast. The company is also a major producer of private label lubricants that are marketed under nationally recognized consumer and commercial brand names and is the largest producer of zinc-free diesel locomotive engine oils east of the Mississippi.

Discover Thousands of Local History Books
Featuring Millions of Vintage Images

Arcadia Publishing, the leading local history publisher in the United States, is committed to making history accessible and meaningful through publishing books that celebrate and preserve the heritage of America's people and places.

Find more books like this at
www.arcadiapublishing.com

Search for your hometown history, your old stomping grounds, and even your favorite sports team.

Consistent with our mission to preserve history on a local level, this book was printed in South Carolina on American-made paper and manufactured entirely in the United States. Products carrying the accredited Forest Stewardship Council (FSC) label are printed on 100 percent FSC-certified paper.